D1104017

LANGPORT & HUISH EPISCOPI

THROUGH TIME

Janet Seaton

Langport & District History Society

Janet Seaton

AMBERLEY PUBLISHING

Acknowledgements

This book would not have been possible without the immense help and support of Colin Edwards and Jo Stradling, whose abilities with cameras and scanners and their knowledge of the local area were invaluable to an incomer like me. Others who generously gave their time and expertise were: Pauline Burr, Yvonne Crabbe, Pat & Allan Edwards, Andrew Lee, Clifford Lee & David Holmes, Simon Martin, Sandy Michell, Dennis & Mary Sheppard, staff at the Somerset Heritage Centre, Sue Standen, Emma Vendome Taylor, Robert Webb and Barry Winetrobe.

In addition, our grateful thanks also go to the following people who have allowed us to use their images: Pam Crumb, Gladys Dagworthy, Laurina Deacon, Colin Edwards, Tricia Everitt, Linda Hulin, John Hunt, Alan Keirl, Andrew Lee, Eileen Lock, Janet O'Hare, the late Bob Perry, the Pittard family, Heather Ridgway, Julia Rogers, David Root, Dora Sandford, Annie Shillabeer, Somerset Heritage Centre, Jo Stradling, and Robert Webb.

We have made every effort to find the owners of images and seek their permission to reproduce them. We apologise if we have inadvertently used any images without permission. We also welcome any information readers can provide to fill in the many gaps in our knowledge of, or any factual errors about, the photographs and accompanying text in this book. The Langport & District History Society of course welcomes any new images and information that will further illuminate the rich history of Langport and Huish Episcopi.

First published 2013

Amberley Publishing
The Hill, Stroud
Gloucestershire, GL5 4EP

www.amberley-books.com

Copyright © Janet Seaton, 2013

The right of Janet Seaton to be identified as the
Author of this work has been asserted in accordance
with the Copyrights, Designs and Patents Act 1988.

ISBN 978 1 4456 1087 0

All rights reserved. No part of this book may be
reprinted or reproduced or utilised in any form
or by any electronic, mechanical or other means,
now known or hereafter invented, including
photocopying and recording, or in any information
storage or retrieval system, without the permission
in writing from the Publishers.

British Library Cataloguing in Publication Data.
A catalogue record for this book is available from
the British Library.

Typeset in 9.5pt on 12pt Celeste.
Typesetting by Amberley Publishing.
Printed in the UK.

Introduction

Langport and Huish Episcopi live side by side in the heart of England's West Country. Based at a crossing point over the River Parrett, Langport's central location is crucial to its history and development as a hub for the surrounding rural communities. In the nineteenth century its prosperity was founded on river trade, but this declined as railways sped up the distribution of goods, and it was replaced by banking, business and retail trading. Huish Episcopi remained a largely agricultural community, with milling, quarrying, tanning and plant nursery industries.

In the twentieth century the closure of the two railway stations returned the area to its rural roots and renewed its reliance on the road network. Like many historic towns, the volume of traffic through the narrow streets is a problem.

Today, the combined population of the Langport and Huish area is around 3,000. Langport flourishes as a market town, hosting most of the area's civic amenities, services and shops. Because it is bounded on two sides by the River Parrett, most of the post-war housing development has necessarily been in Huish.

The area is perhaps best known for a famous Civil War battle, the Battle of Langport on 10 July 1645, in the aftermath of the decisive Parliamentary victory at Naseby. The Parliamentarians under Sir Thomas Fairfax defeated Lord Goring's Royalist forces, and cleared the way for Roundhead control throughout the West. The Sealed Knot staged a re-enactment of the battle in 1995, to mark its 350th anniversary.

The celebrated Victorian journalist and author, Walter Bagehot, hailed from Langport, and the family bank he worked for, Stuckey's, was one of the leading provincial banking groups in the nineteenth century. At one time it had a banknote circulation second only to the Bank of England itself.

Huish Episcopi is the home of the Kelways Nurseries, which have operated for over 160 years. Kelways gained a worldwide reputation for

peonies, gladioli and irises, and won medals at shows both nationally and internationally, from Chelsea (regularly) to the 1904 Exhibition accompanying that year's Olympics in St Louis, Missouri.

Members of the Langport & District History Society have compiled this book as a celebration of the heritage of our local area. We have been collecting digital images of local postcards and photographs for several years, so the *Through Time* format is an ideal way to display some of them in an accessible form.

In our selection we have tried to include as many views as possible that are not particularly well known. Our appeals for people to share their old photographs have been very successful. By taking a scanner and laptop with us to people's homes we have been able to reassure them that their photographs will not get lost, since they never leave their possession. We were also fortunate in being able to access the Denman Collection of photographs in the Somerset Heritage Centre. We have tried to include relevant factual information to give the images some context. As a result, we hope this book will shed new light on our local history, and interest residents and visitors alike.

The book is arranged so that it can be followed as a circular walking tour, with a few detours. It starts to the west, at Hurds Hill, and goes up Bow Street and Cheapside. At the post office it turns left into North Street, then follows Somerton Road, Field Road, round to Eli's pub and then down to the River Parrett at Huish Bridge. Using Bennett's Lane to cut back from the riverbank to the Hill, the route turns left, returning to the town at the post office.

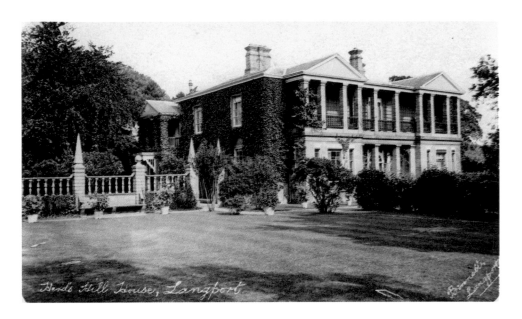

Hurds Hill

This was the family home of Walter Bagehot, economist and journalist. It is said that in 1826 he was carried, as a babe in arms, to see the foundation stone being laid. Walter abandoned his law career in London to return to Langport in 1852. He died at Herd's Hill (as it was then known) in 1877 and was buried in Langport. A nursing home for many years, it has now returned to its original use as a private residence.

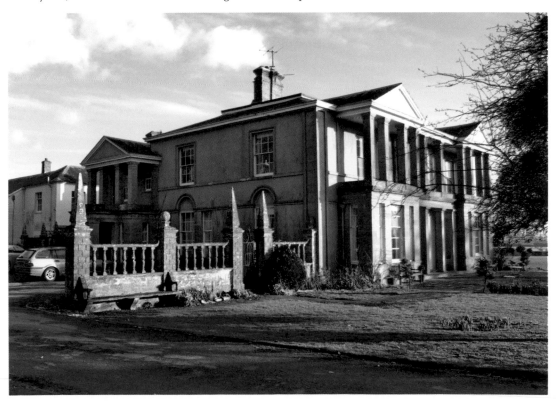

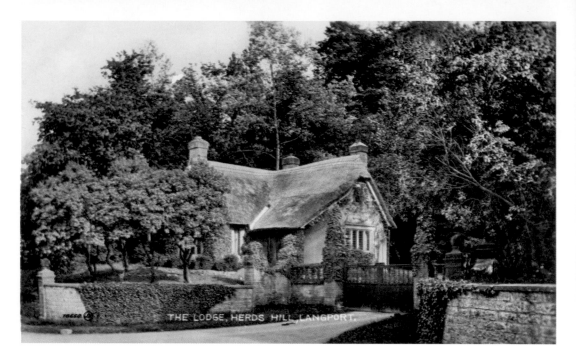

Hurds Hill Lodge

The Hurds Hill area (originally spelled Herd's Hill) actually lies in the adjacent parish of Curry Rivel, but its indelible association with the Bagehot family make both Hurds Hill House and its Lodge an integral part of Langport's history. Like the house, the Lodge was built in 1826. Its occupant in 1841 was described as a 'gatekeeper', and later residents were gardeners to the estate. The Lodge is no longer the entrance to Hurds Hill House.

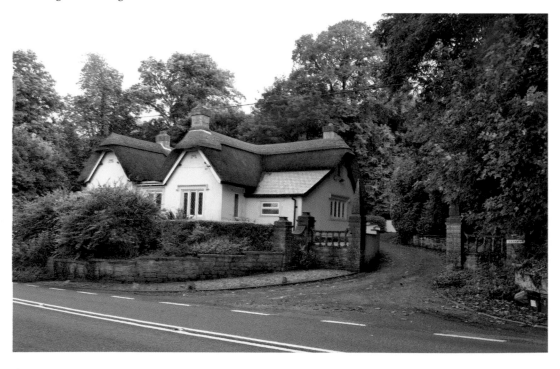

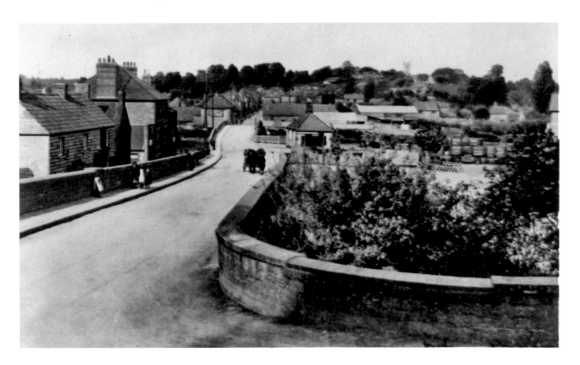

Langport from Hurds Hill

It was along this route that Lord Goring's Royalist forces fled in July 1645 after their defeat at the Battle of Langport. They set fire to many of the houses in Bow Street as they retreated towards Bridgwater, but they did not have time to destroy the old medieval bridge over the River Parrett. This view of the railway bridge in the foreground and the 1841 Bow Bridge in the background remains the same even after more than 100 years.

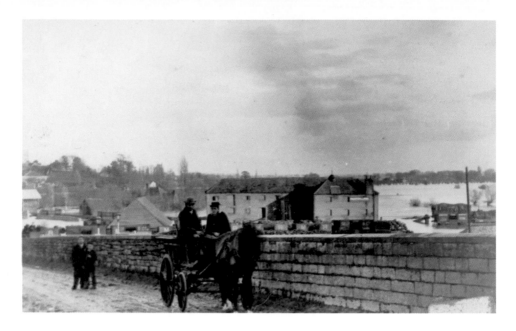

Langport Westover

The road was raised to take it over the railway line at Langport West station, so perhaps the people in the horse and cart are looking over the parapet at the new form of transport that was to transform the fortunes of the town. The large warehouse in the background belonged to Bradford & Sons, who were timber, slate, corn, coal and salt merchants. The trading estate on the site today is still at risk of the flooding that can be seen in the background of the older photograph.

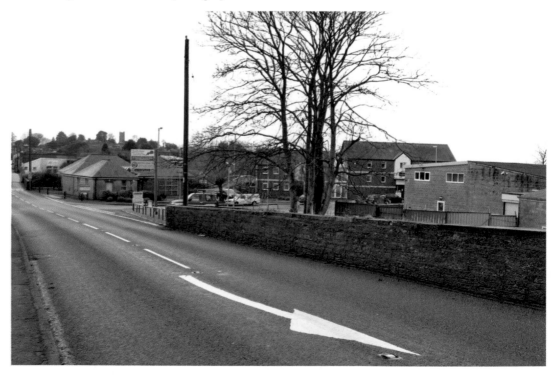

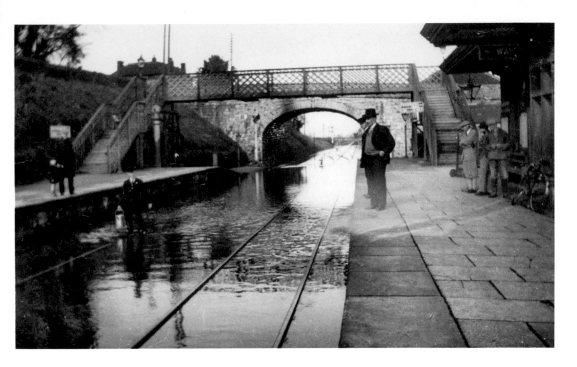

Langport West Station

Langport station was opened by the Bristol & Exeter Railway in October 1853, on a branch line linking Yeovil and Taunton. It was renamed Langport West when a second station opened in 1906 on a new line at Langport East. As can be seen, it was prone to flooding. The station closed in 1964 and now only the railway arch remains.

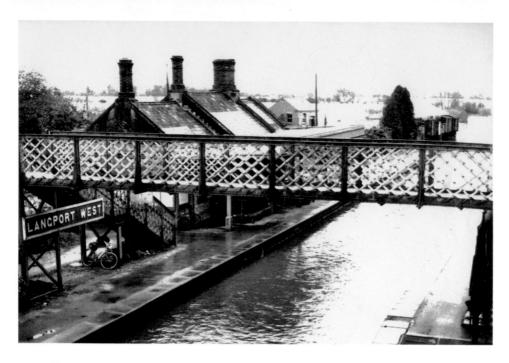

More like a Canal than a Railway Station
This 1960 photograph of Langport West station shows deep floods almost up to platform level. The station buildings and the footbridge have now all been demolished and replaced by a busy but unattractive industrial estate. Flood prevention measures, including a pumping station on the River Parrett nearby, have reduced the frequency and severity of the floods.

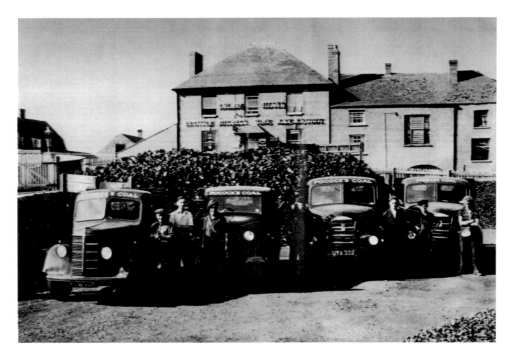

The Railway Hotel

The Railway Hotel was built around 1908. As the main road had been raised to go over the railway arch at Langport West station, the building's entrance was cleverly designed to be at first floor level. Access was over a 'scissor type' iron bridge, which had to swing to the side to allow lorries to pass underneath. Pocock's loaded coal from railway trucks in the sidings and took it to their own coal yard in Bow Street. The sidings now form part of the Westover Trading Estate, and the Railway Hotel has been converted into flats.

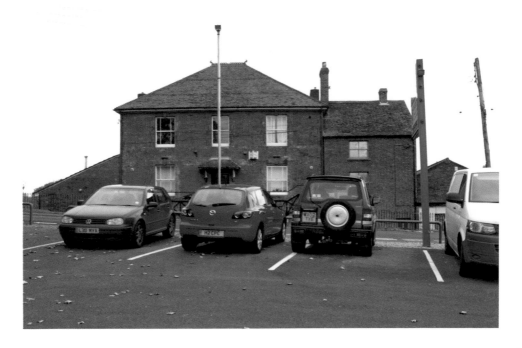

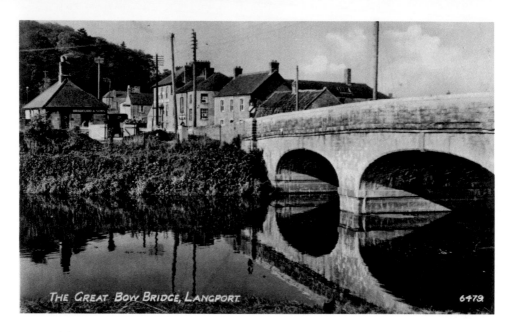

Bow Bridge

This strategic river crossing point gave Langport its traditional prosperity as a trading centre. The River Parrett was navigable from Bridgwater to Langport, where goods were unloaded and taken either upriver in smaller boats or further afield by road. The medieval bridge over the River Parrett had nine arches, but these restricted the river trade. In 1841 it was replaced by this bridge of three arches, designed by William Gravatt, an associate of the famous engineer Isambard Kingdom Brunel.

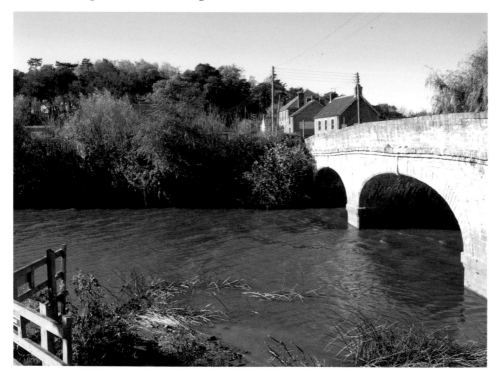

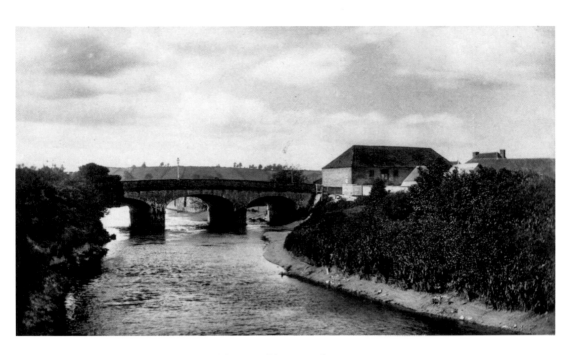

Bow Bridge and Cocklemoor Bridge, Looking North

The salt warehouse at Great Bow Wharf, seen at the eastern end of the bridge, was the headquarters of the influential Stuckey & Bagehot trading business (later the Somerset Trading Co.). Their Parrett Navigation Co. instigated many improvements to river navigation. The old 1841 bridge appears to be holding up the new footbridge leading to Cocklemoor, which was opened on 13 November 2006.

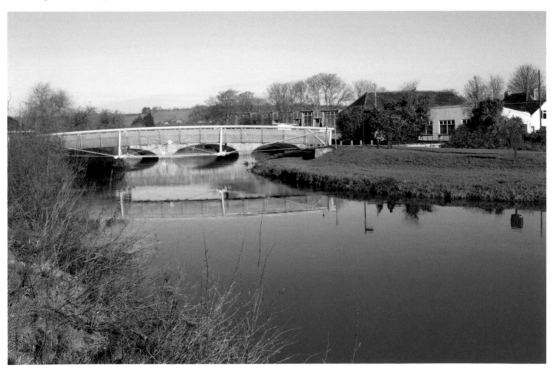

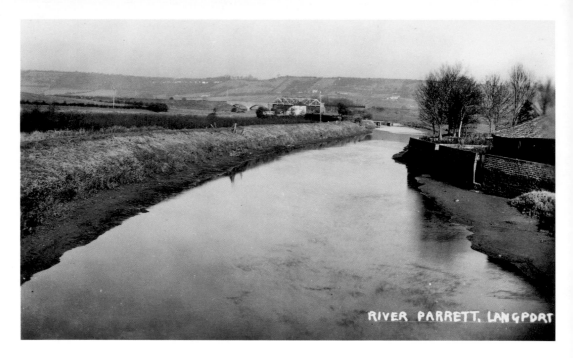

RIVER PARRETT, LANGPORT

River Parrett from Bow Bridge

This tranquil view, looking north, shows how narrow the River Parrett is at Langport. The wharf used by Stuckey & Bagehot's trading business was on the right. Now only the salt warehouse remains, which is flanked by an award-winning development of twelve low energy eco homes, one of which can be seen on the right.

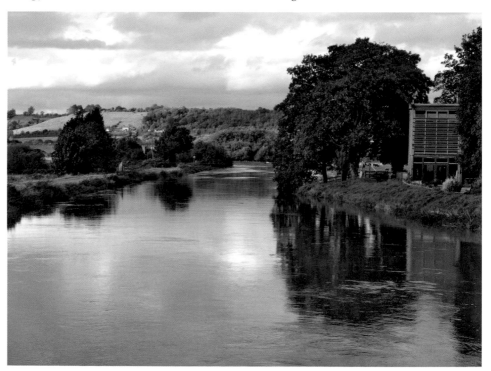

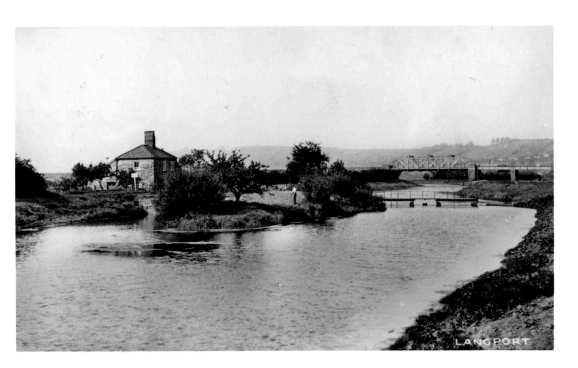

Langport Locks

Locks and floodgates were built across the River Parrett in 1839 as part of improvements made by the Parrett Navigation Co. They had fallen into disuse by 1878, but the sluice gates were removed only a few years ago. The 1906 girder bridge for the Castle Cary to Durston railway line is visible in the background. The river below is very high after the flooding in the winter of 2012.

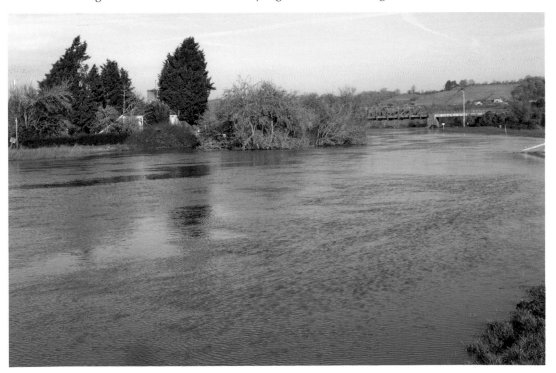

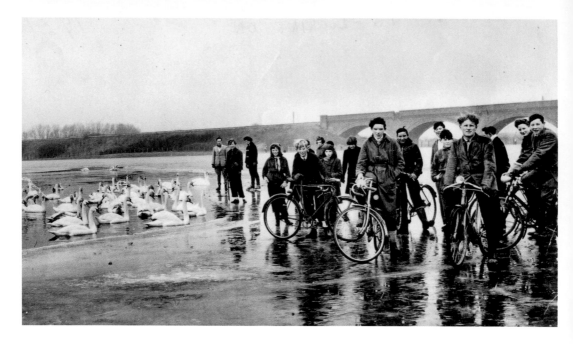

North Moor

Building the railway line from Castle Cary to Durston involved spanning the flood-prone moors at Langport. The brick viaduct had to be sunk 75 feet into the ground. These cyclists and skaters are enjoying the ice in the harsh winter of 1962/63. North Moor still floods regularly, but ice skating is seldom possible. Commoners have grazing rights on the moor, and the proceeds of the sales of the grass are divided between them.

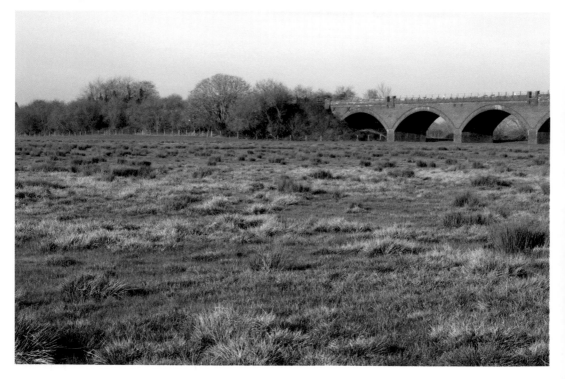

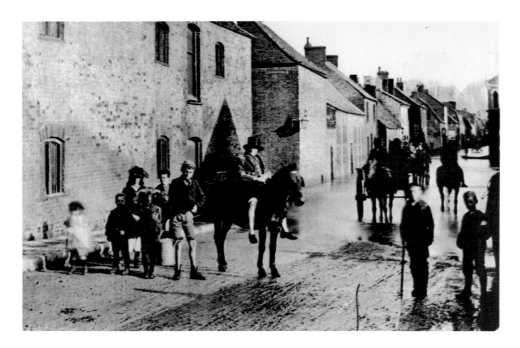

Great Bow Wharf Warehouse

This is one of the few old photographs that have come to light featuring the Great Bow Wharf warehouse. The children look as if they have been deliberately positioned, but the occasion is unknown. For many years it was occupied by the Silkolene Works. The warehouse remains one of the most prominent sights for people entering Langport from the west on the A378, although nowadays you see more shadows, fewer people, and usually more road traffic!

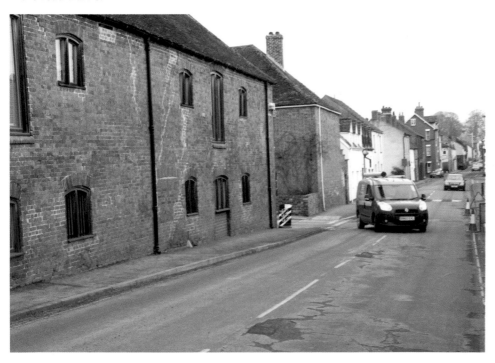

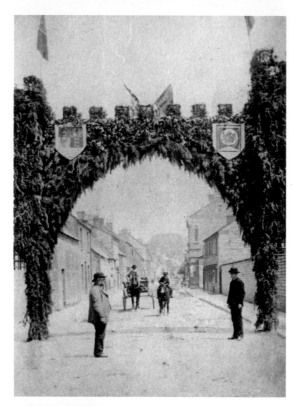

The Jubilee Arch Over Bow Street
This magnificent ornamental archway was installed for Queen Victoria's Diamond Jubilee in June 1897. It is decorated with greenery, flowers, flags and shields. The smaller arches over the footpaths each have a portcullis; Langport's emblem derived from the arms of its fifteenth-century patron, Lady Margaret Beaufort. Pedestrian safety has been improved, but otherwise today's street shows little change.

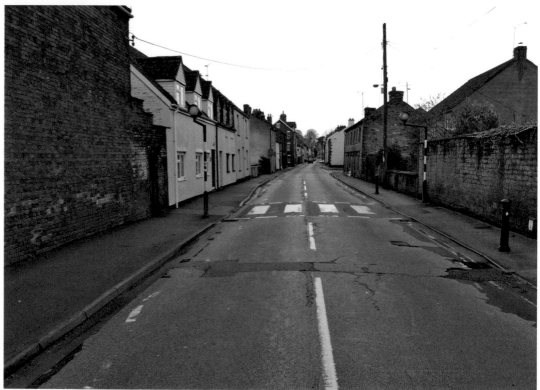

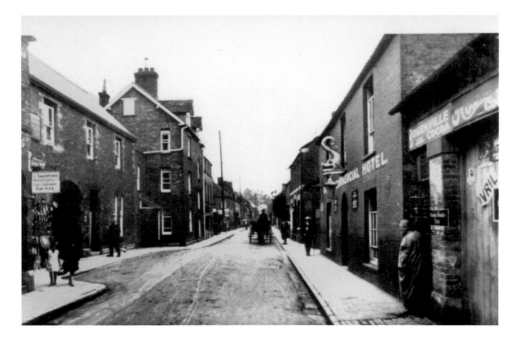

Bow Street – the Main Thoroughfare

The notice on the left advertises Charlie Sandford's charabancs, a business he started in the early 1920s. The coaches went at a top speed of 12 mph, and were popular for outings to places such as the Cheddar caves. He's driving this one himself. Opposite is the Dolphin Hotel, first mentioned in 1778, a popular commercial inn which is sadly now closed. The superb dolphin itself has been saved and is on display nearby.

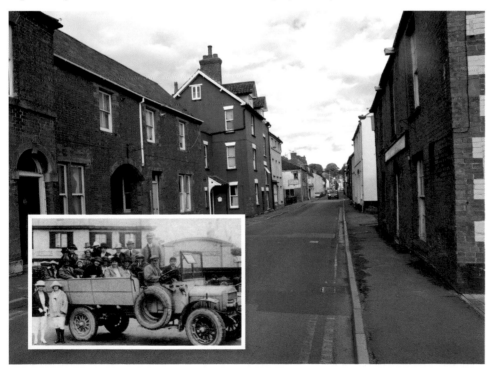

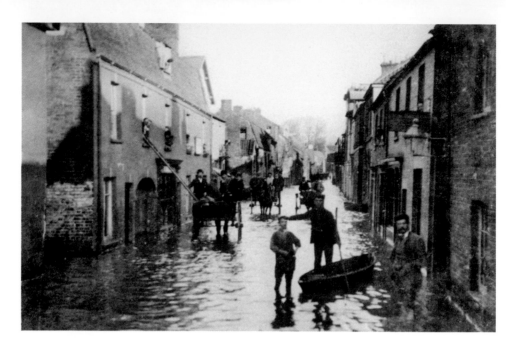

Bow Street Under Water

Flooding is a regular feature of life on the Somerset Levels. This severe episode took place in or before 1894. The ladder on the left is against the house where Phineas Winter Webb was soon to open his bakery, which is now a fast-food takeaway. The old Spread Eagle Inn is at the far end of the building. Flood prevention measures have lessened the risk, but in late 2012 there were fears that Bow Street would flood again, and sandbags were issued. Fortunately, they were not needed.

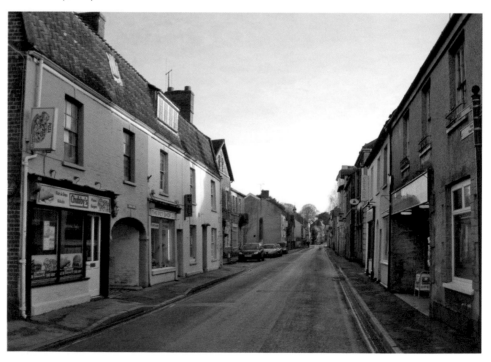

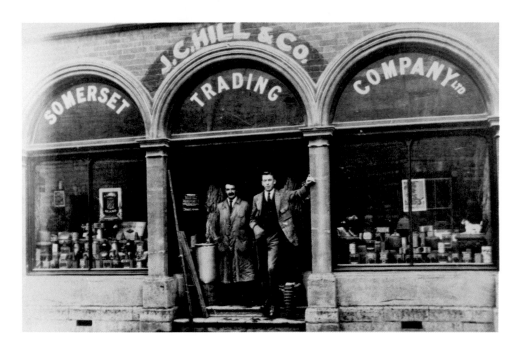

Bow Street Traders

The Somerset Trading Co., established in 1883 and listed in that year's *Kelly's Directory*, had developed out of the Stuckey & Bagehot business. This is probably John Charles Hill with his assistant, Thomas Cullen. They sold seeds and garden supplies, including 'canary guano'. Today a firm of funeral directors operates from these offices with their dramatic arched windows.

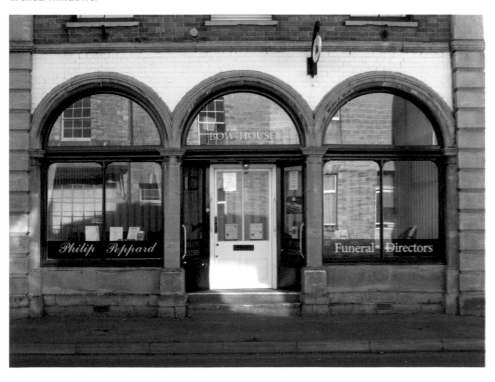

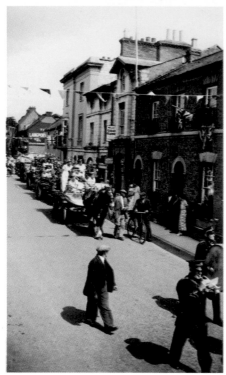

Langport Loves a Parade

This Coronation themed parade in 1937 is passing three buildings of architectural interest on the south side of Bow Street, featuring the use of the local white lias stone: Blake House, Arlington House and Bow House. Arlington House was the home of William Atyeo, a skilled stonemason, who was in business here between around 1842 and 1872. His name is carved in the stonework above the door. A touch of colour brightens up the street today.

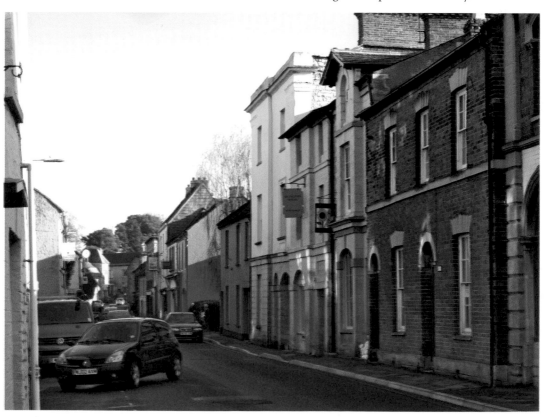

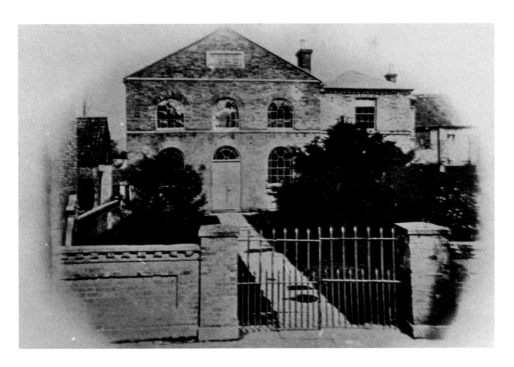

United Reformed Church

Langport Congregational chapel was first built on this site in 1828 with seating for 250, and the manse beside it was added in 1850. Due to frequent flooding, however, the façade had to be replaced in 1875. The floors were raised by several feet and set on brick piers. Today the overgrown trees completely obscure the view from the front gates.

The Changing Face of Business

This pair of photographs demonstrates that sometimes a redevelopment can improve a site. The arched entrance and the new windows in the Old Book Shop have smartened up this bit of the south side of Bow Street. Derek Ridgway, who ran the bookshop with his wife Heather, was instrumental in the building of Ridgway Hall, a community facility in nearby Stacey's Court.

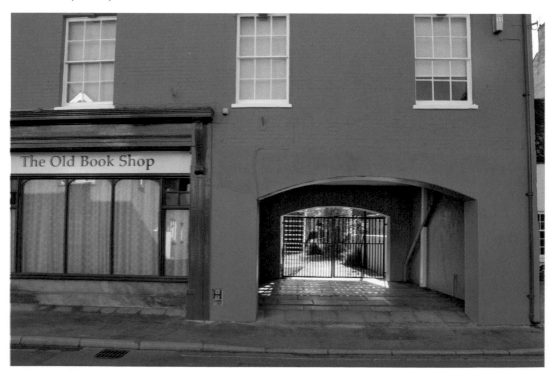

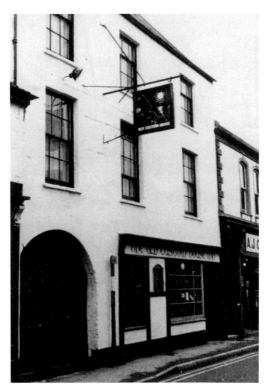

The Angel

The original inn on this site, built in 1760, was called the Angel. At one time its skittle alley doubled as a rifle range. Later it became the Old Custom House Inn, but declining trade saw it sold in 2009 to a church charity, which restored its old, and perhaps more appropriate, name of the Angel. It now operates as a community centre.

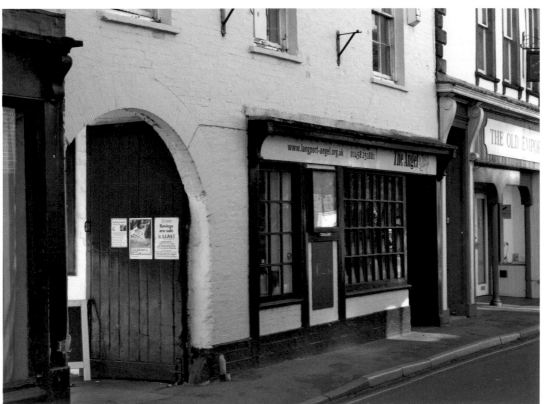

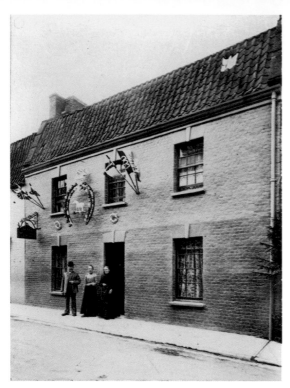

The Residence of Christopher Shire, Blacksmith

Local trade directories list Christopher Shire as a blacksmith in Bow Street between 1897 and 1939. He lived there with his wife Ellen, who was a dressmaker. The forge was behind the house, with access next to the wall of what was the Congregational chapel. This building, and the one to the left of it, have both been demolished, and replaced by a hairdresser, and a house called Poppins, from where Charlie Sandford later ran his charabanc business.

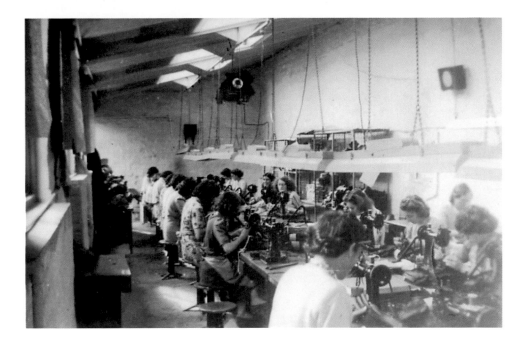

Glove Making

Ensor House, built in the mid-eighteenth century, was at some stage named after Thomas Ensor, a prosperous glove manufacturer from Milborne Port who ran a business here in the 1930s. Although called a glove factory, latterly it was a 'making station' for pre-cut leather supplied from Tintinhull. Between thirty and forty people were employed, mostly women, with many more 'outworkers'. Dents Gloves closed in 1971, ending Langport's connection with this traditional Somerset industry.

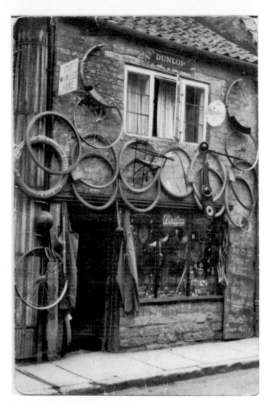

A Cycle Shop
This looks like an early view of Fred Head's cycle shop. In later photographs the shop is on the other side of the butcher's shop, with a much grander shop window. The narrow pavements are characteristic of Bow Street, but the block of flats that replaced the cycle shop has been set back from the road to give more space.

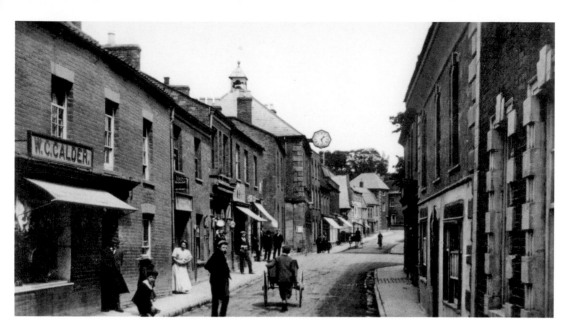

Butchers of Bow Street

The Calder family and the aptly-named Cattle family were butchers in Bow Street in the nineteenth century. Intermarriage produced William Cattle Calder, who inherited his father's business in 1880. There were Cattle and Calder butcher's shops until the 1930s, and this shop, on the north side of Bow Street, is still a butcher's.

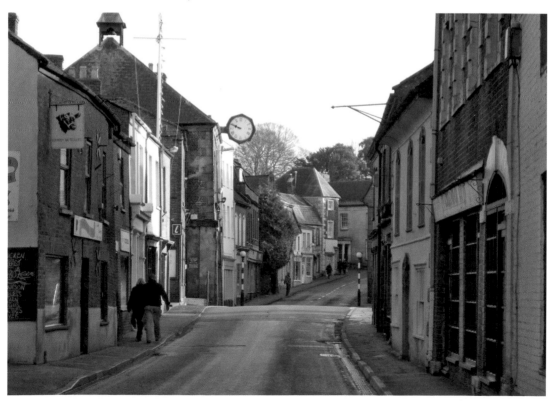

Bow Street, Looking West

Bow Street is very narrow – a mere 14 feet and 6 inches (4.4 m). It is built on a Roman causeway over the moor, and many of the houses lean backwards as they sink into the peat. The wicker chairs on the right outside Henry Coate's shop are still a traditional Somerset willow product, though no longer sold in Bow Street. The Market House with the sign on the left, once an inn, is now a private house.

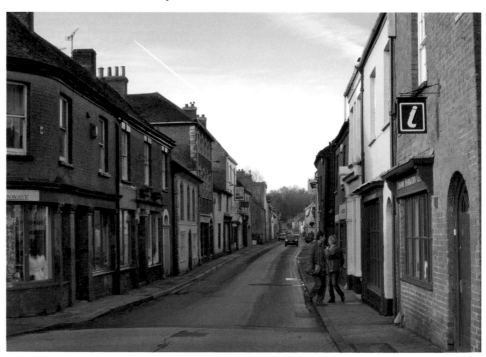

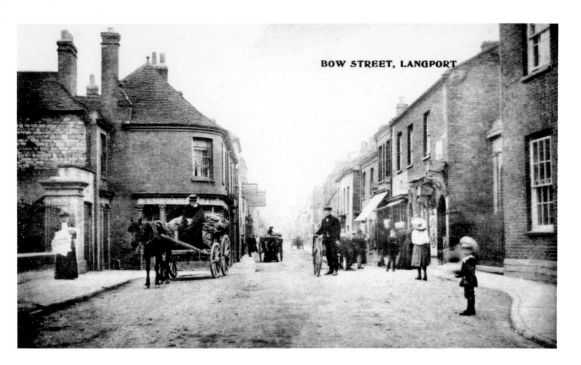

BOW STREET, LANGPORT

Little Bow Bridge

The photographer is standing on a hump in the road, which is called 'Little Bow Bridge'. Mention of Little Bow Bridge as 'lytylbryge' can be found as early as 1268. It crossed the Catchwater, which fed into Portlake Rhyne to the north and joined the river below the locks. The bridge was rebuilt in 1800 and widened to the south in 1875. The curved building on the left, formerly Browns the bakery, is now a charity shop.

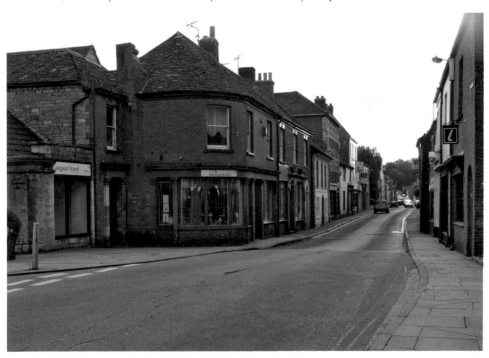

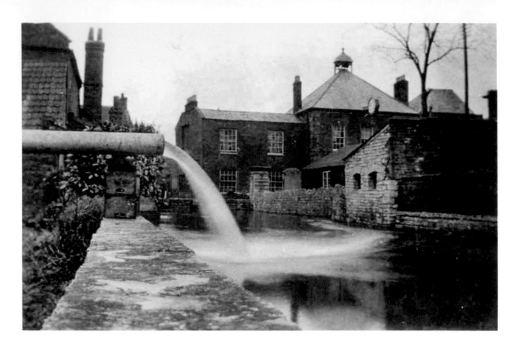

The Catchwater

The pipe is discharging into the Catchwater, which was built after complaints from the owners of low-lying land upriver that their fields could not drain into the river because its level was raised by the locks. The west side drained under the river through an inverted siphon. In 1968 much of the Catchwater was covered over or filled in to make way for the development of a parade of shops, Parrett Close.

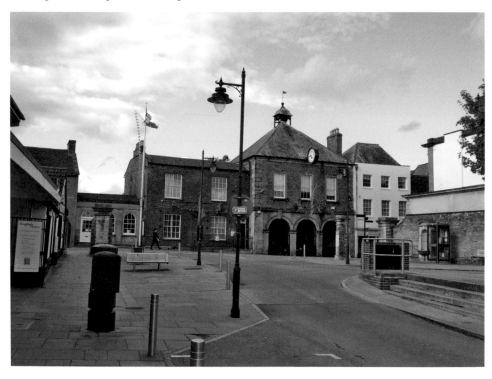

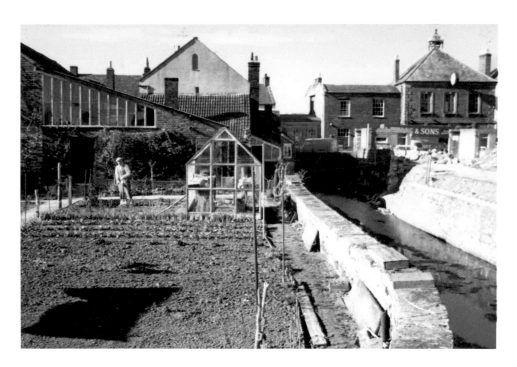

The Building of Parrett Close
The produce that was once grown on the site is now delivered from elsewhere to the shops that were built here in the 1960s. A large car park was built between Whatley and the Cocklemoor to cater for shoppers and visitors. Notice how the line of the pavement seems to echo the curve of the Catchwater wall.

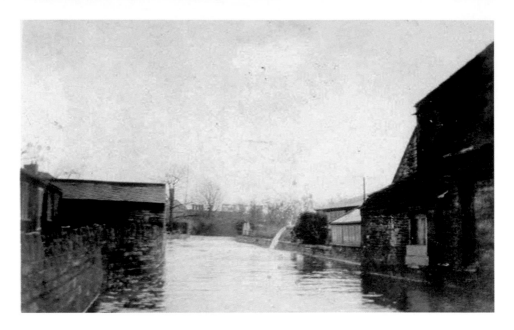

The Catchwater from Little Bow Bridge

A youthful Ken Crumb stands in front of the view of the Catchwater looking south. The Parrett Close shops cover the area now, but the Catchwater can be seen again at the end of Whatley, where it turns to follow the course of the River Parrett below The Hill. The area on the left was a pig market between 1855 and 1937, when it became a car park.

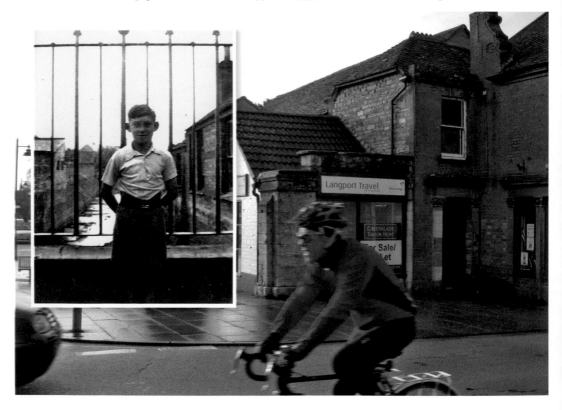

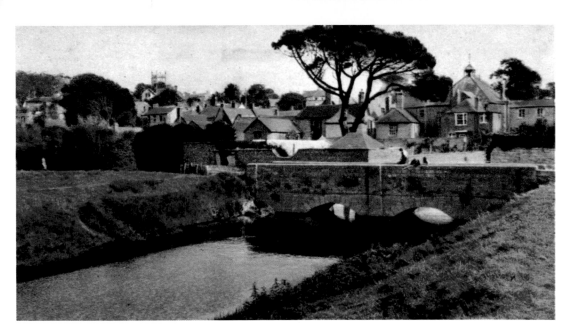

A Rear View of the Town

This postcard shows an unusual view of the Catchwater, taken from North Moor, and was postmarked 1907. The back of the Town Hall is on the right of the scene, and the tower of All Saints church can just be seen peeping over the trees on the left. Behind the Town Hall today lies the Walter Bagehot Town Garden, displaying a restored drainage pump that was used to save the town from flooding in the 1960s.

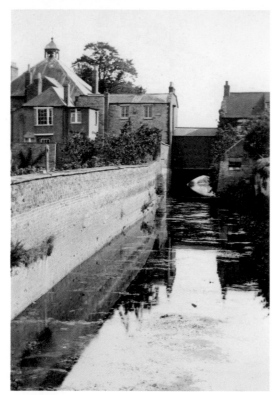

The Catchwater from North Moor
The register office, which was built on steel girders on Little Bow Bridge in 1837, can clearly be seen spanning the Catchwater at Bow Street. The area behind the wall on the left, behind the Town Hall, is now the Walter Bagehot Town Garden. The Catchwater channel to North Moor is now just an overgrown ditch.

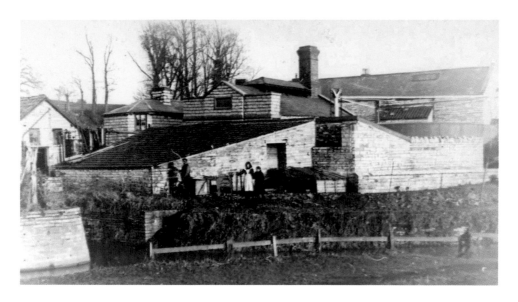

The Gasworks

The gasworks were established at Whatley in 1835, when the Langport Coal Gas Co. was formed. In 1902 it supplied gas to light the town's street lamps. The plant closed in August 1955 but was retained as a gasholder station until September 1964. An original window (the third from the left, above) can still be seen, incorporated into a house in a development on the same site.

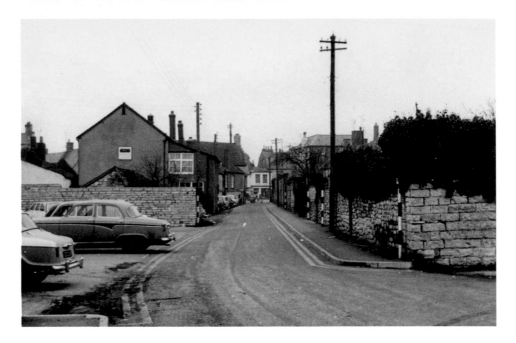

Whatley

The Whatley area was originally a common where horse fairs were held. In 1829 it was mapped and building plots were laid out for housing. Langport Library on the left (with the clock) was opened in November 1994. Looking north, Cheapside can be seen in the background, and off to the right, Whatley Lane rises steeply up the hill.

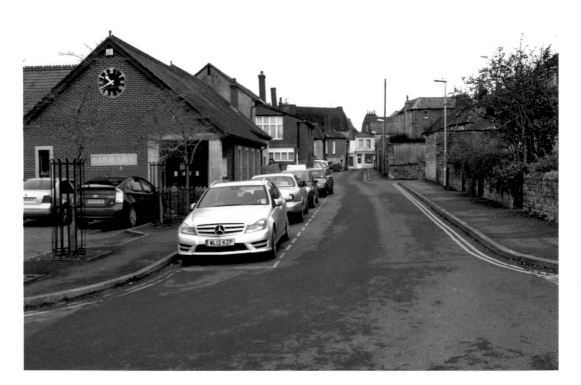

Sunnyside Cottage, Whatley

This cottage, heavily buttressed against Whatley Hill, stood at the end of Whatley, facing the Catchwater. It was formerly the White Swan, an inn frequented by boatmen plying their trade along the River Parrett. Owned by the Webb family, who ran a bakery in Bow Street, the hill behind it provided winter grazing for Tom, the bakery horse. It was demolished in the 1950s and the stone taken away for reuse.

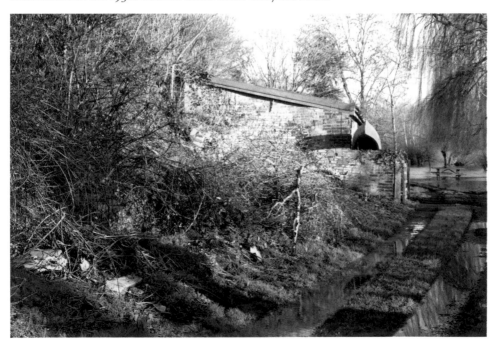

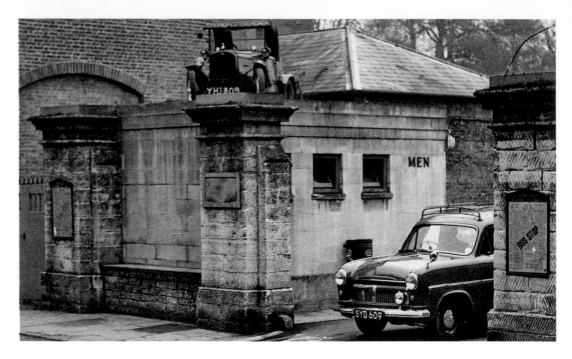

A Little Local Entertainment

How this old Austin Seven came to be parked on the roof of the men's toilet is known only to those who played the trick on their friend in the early 1960s. The toilets have since been demolished, leaving the two grand pillars in front, and replaced by a modern block nearby.

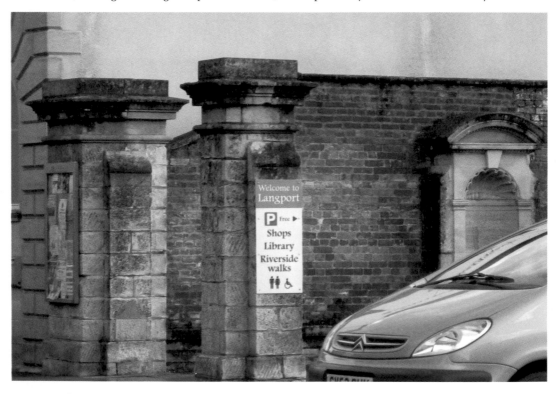

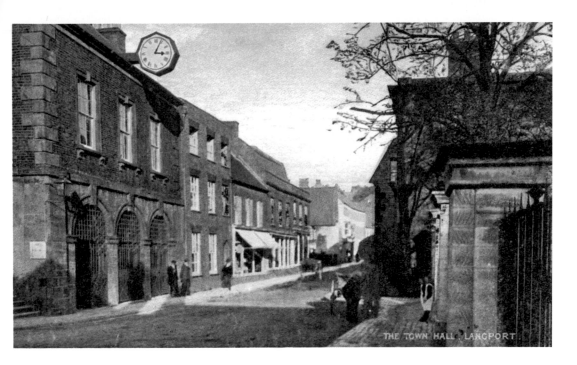

Langport Town Hall

The Town Hall was built in 1732, and the three pairs of iron gates in the arches were fitted in 1840. The top of each arch is designed as a portcullis, Langport's emblem. The octagonal Town Clock, replacing one originally installed in 1802, dates from 1883. At one time the parish fire engine was housed underneath, and in the nineteenth century a market was held there. It is still leased out as a shop.

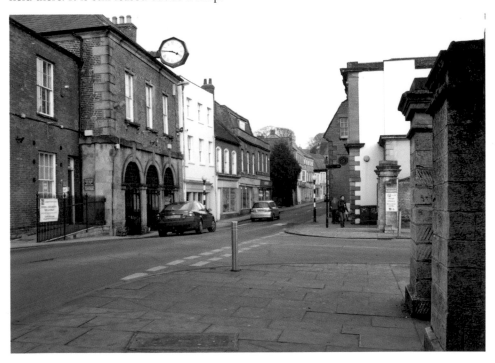

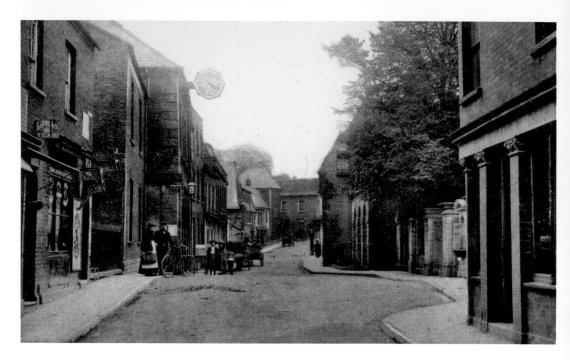

Little Bow and Cheapside
'Cheapside' is derived from 'ceap', the Saxon word for market. Originally the market was on The Hill, but it was gradually moved down towards the river. The drinking fountain, with its curved top, can just be seen on a pillar on the right. It commemorates the Coronation of Edward VII in 1902, and has been relocated inside the gates. The shop on the left is now the Langport Information Office.

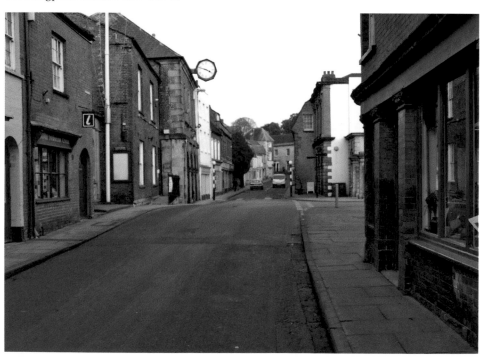

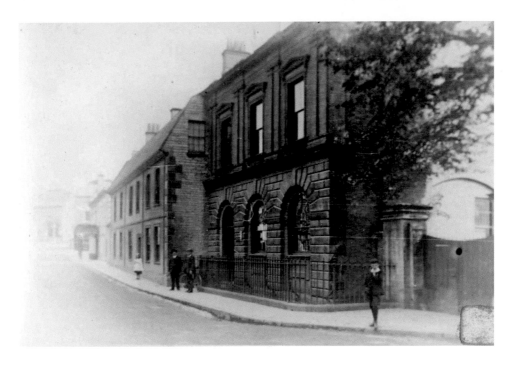

Langport's Contribution to Banking History

Bank Chambers, the building on the left with a mansard roof, is the birthplace of Walter Bagehot (1826–77). It was the site of the original Stuckey's Bank, where Walter's father was the manager. The bank moved to the more imposing Palladian-style building next door, which dates from 1875. Stuckey's Bank once had a banknote circulation second only to the Bank of England. It eventually became part of the NatWest Bank, now part of the RBS Group.

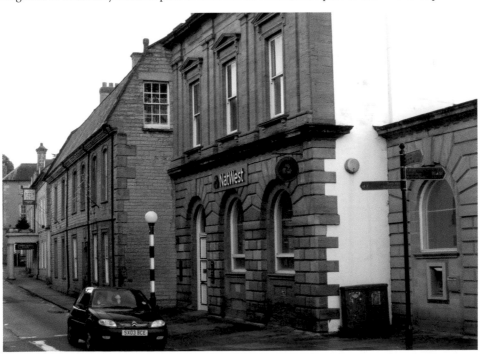

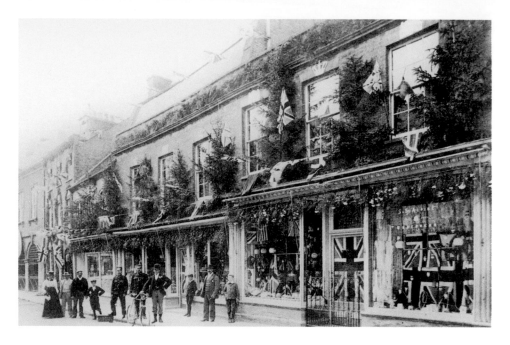

The County Stores

The 1901 census records nineteen employees living on the premises of this Cheapside department store. Ten years later Francis Meade & Co. had twenty-four live-in workers. Known as the County Stores in the 1930s, it traded until the 1970s. Judging by the dress, this celebration could have been for the Coronation of Edward VII in 1902. A bookshop and a charity shop occupy these premises today.

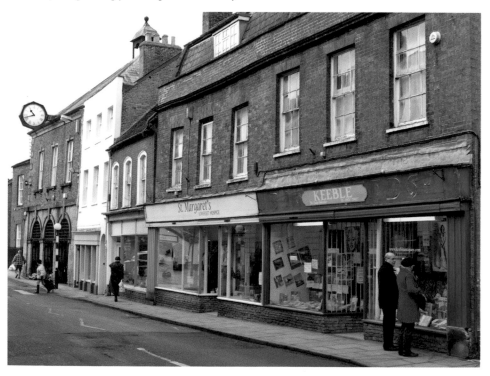

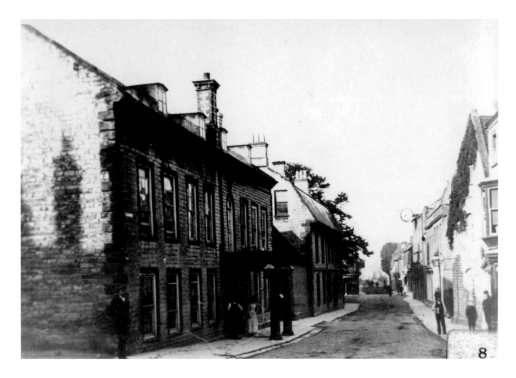

The Langport Arms

The Langport Arms on the left with its Tuscan-style porch dates from the fifteenth century. For many years it was a coaching inn. In the sixteenth century it was just called the Inn; in the seventeenth and eighteenth centuries it was called the Swan, but it has been the Langport Arms since the early nineteenth century. It is still a pub and hotel.

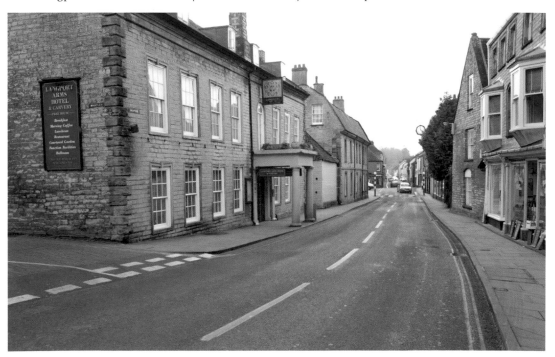

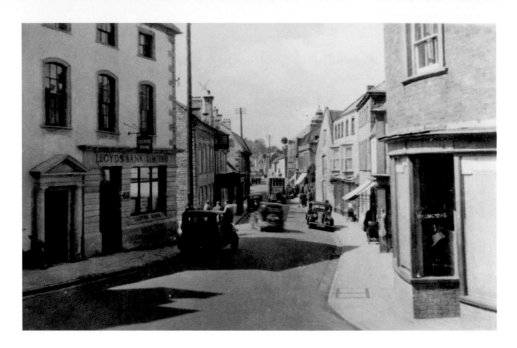

Other Banks Have Come and Gone

Fox, Fowler & Co., an important West Country private bank, opened a branch in two rooms of Challis' building in 1913. It was the last commercial bank in England and Wales to issue its own notes, until it was taken over by Lloyds Bank in 1921. The pedimented doorway has been removed and the ground-floor frontage is now symmetrical. The branch closed in 1998, but the outline of the bank's lettering can still be seen.

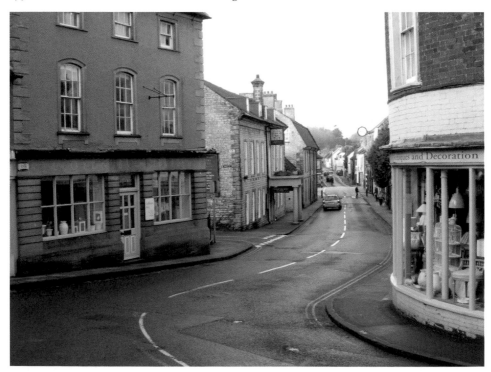

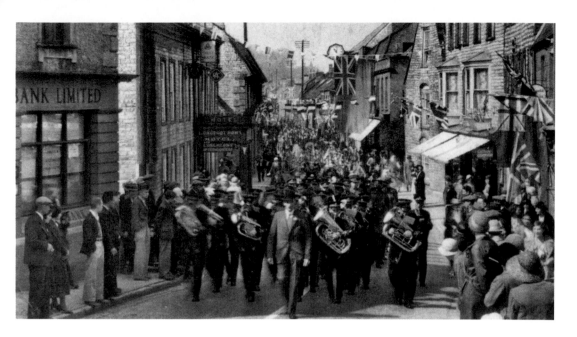

The Best View is from the Post Office

This parade, led by Langport Town Band, is thought to have taken place in the 1920s, but the reason for the celebration is unknown. The main street was thronged again for a different kind of parade on 16 September 2011, when the Tour of Britain cycle race came through the town.

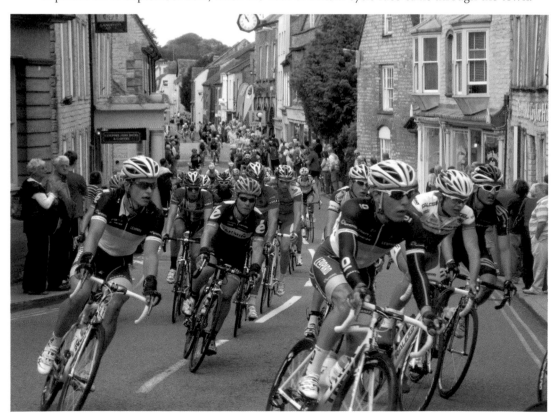

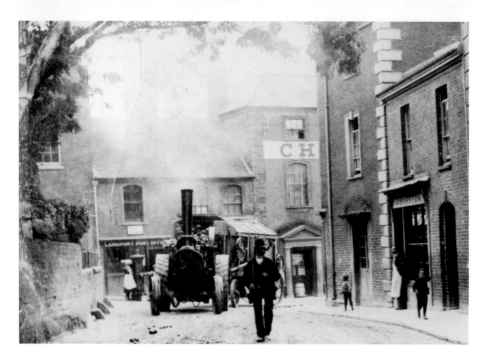

Steam *v.* Diesel

This steam traction engine may have been going from Langport West station to the newly built Langport East station, or it may have had a different purpose altogether. It has just passed Challis' Stores, which sold groceries, clothing, soft furnishings and carpets. The post office (seen behind the engine in the photograph above) is now sited in the building on the left with the Tuscan porch, and steam power has given way to diesel (or petrol).

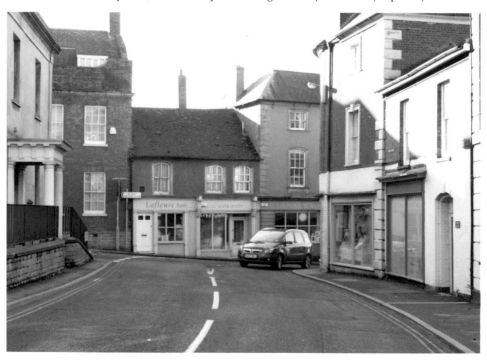

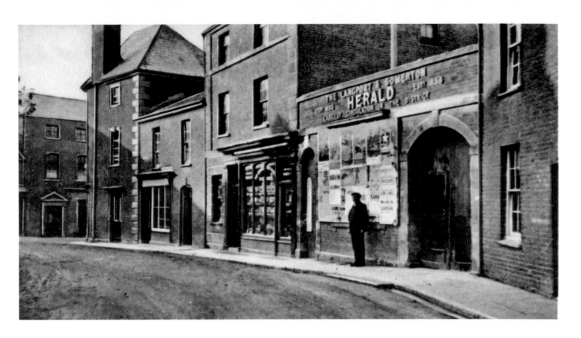

The *Langport Herald*

The first issue of the *Langport Herald* appeared on 7 July 1855. It became the *Langport & Somerton Herald*, and was published until 1937. Founded by James Moreton, later owners were Walter Bennett and G. H. Hemmel. The building with the shopfront window is still known as Herald House, and the *Herald* offices beside it have been converted to residential accommodation.

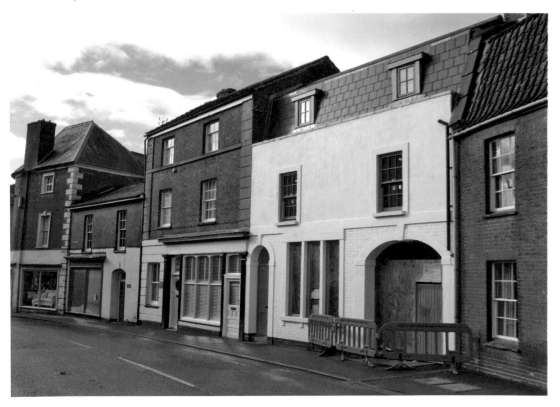

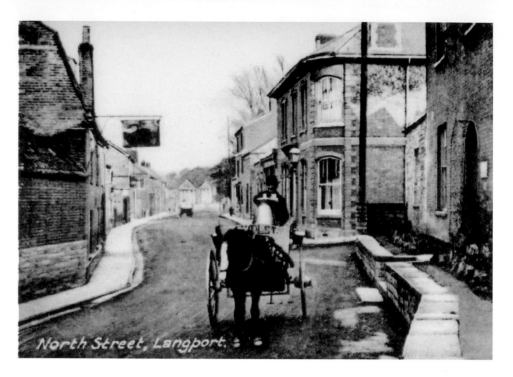

North Street, Langport.

North Street, Looking East

The Black Swan on the left was mentioned as early as 1777, when many inns were needed to meet the needs of the coach traffic that passed through the town. It is now a wine bar and restaurant called Lou Lou's. Downside, the fine corner house on the right, has seen better days.

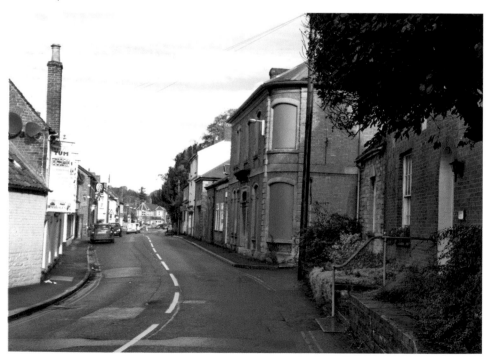

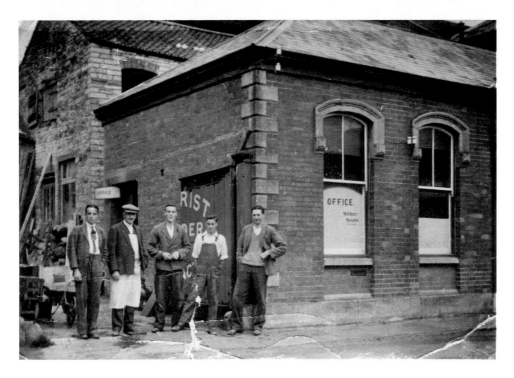

North Street Building Works

William Rist was a builder in Langport for nearly thirty years between the 1920s and the 1950s. He moved to these premises from Bow Street in the early 1930s. Extensive renovations have been made to the building in the background.

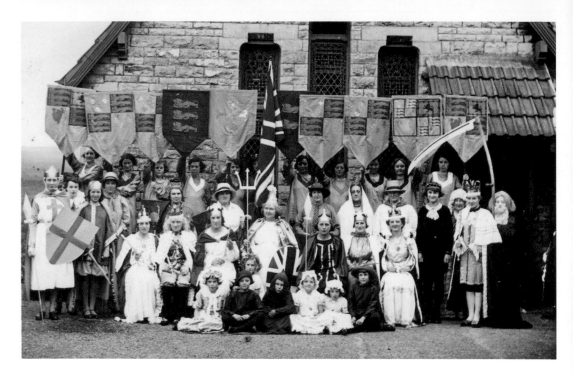

Ladies of the Parish

All Saints Hall was built for the church in 1892. This Women's Institute group in fancy dress could be celebrating the Coronation in 1953. Nowadays the Hall is still a community centre and venue for the popular weekly Langport & District Country Market, with stalwarts Jenny Whitfield, Jean Blackmore, Valerie Wells-King, Anita Emery and Marlene Gibbs pictured here.

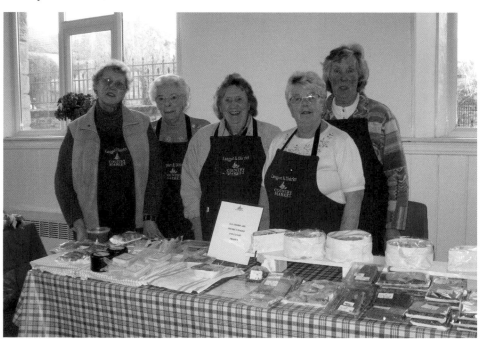

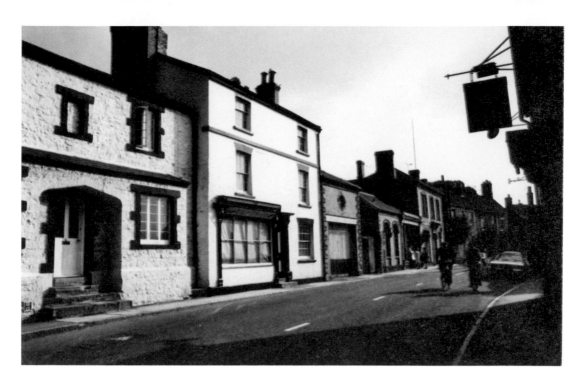

North Street, Looking West

The sign in the shadow is for the White Lion, which probably dates from about 1786, slightly later than its near neighbour, the Black Swan (now Lou Lou's). Once boasting as many shops and businesses as Cheapside, North Street has gradually lost most of them. Mrs Pitman, who owned this ladies and gents outfitter's, is on the left of this photograph, taken on 26 July 1957. The building is now a private house.

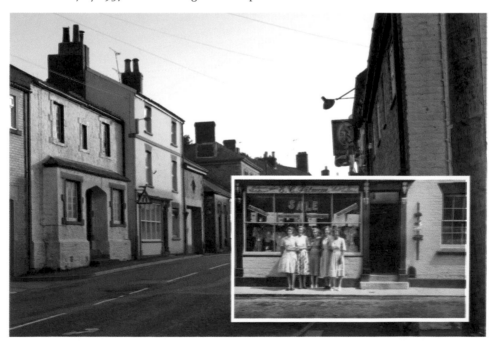

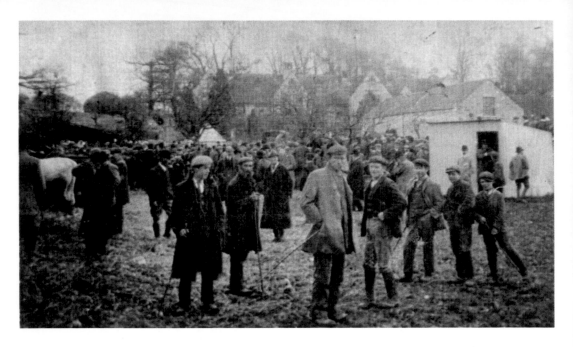

From Cattle Market to Supermarket

Cattle markets had been held in North Street since 1855, but in 1890 they moved to land on the north side, roughly opposite the primary school. In this photograph, taken from the opposite direction, the gateposts can still be seen, but the market has become a DIY store, next to a supermarket.

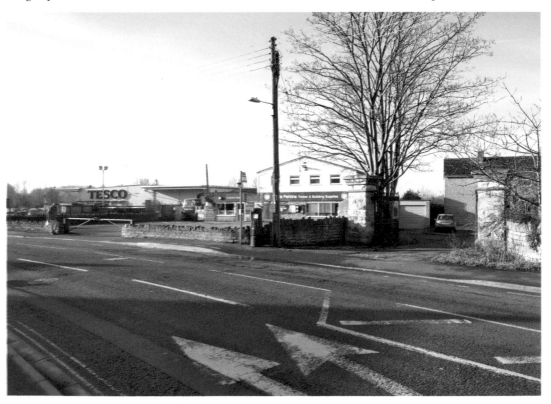

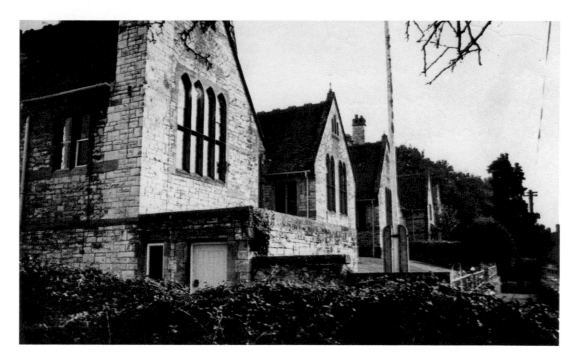

Huish Episcopi Primary School

The Board School, designed by Henry Hall, was erected in 1876 on the site of an Elizabethan farmhouse, overlooking North Street. It has four gables, denoting separate entrances for girls, boys, infants, and the teacher's house. It is now called Huish Episcopi Primary School. The flagpole base is still there, but there's no flagpole.

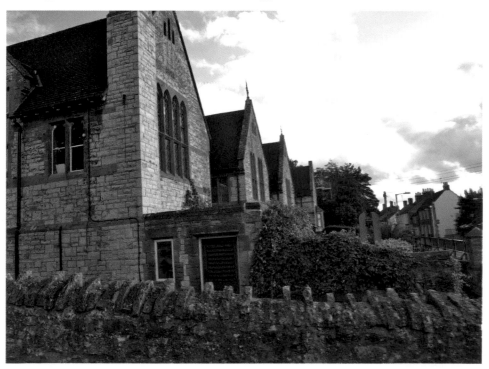

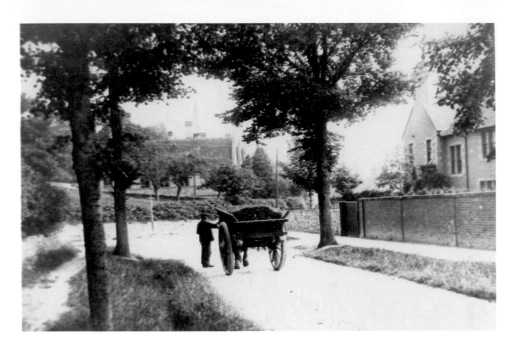

Langport Eastover

Somerton Road, the main road from the east, goes through an old area called Langport Eastover. It was diverted to pass underneath the new railway bridge in 1906. The primary school occupies an imposing position ahead on the left.

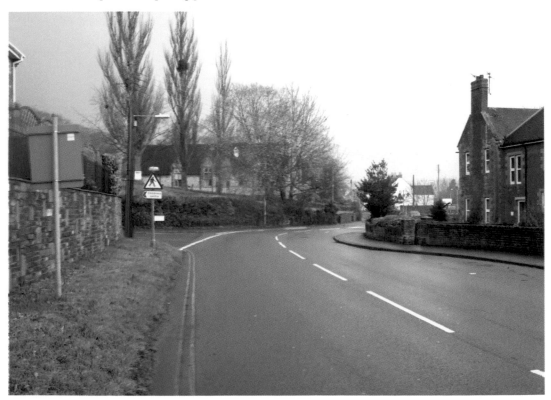

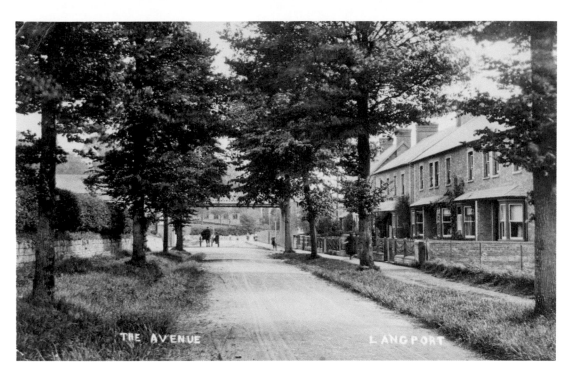

The Avenue

The building of houses in The Avenue began around 1877. The photograph above was taken after the construction of the railway line from Castle Cary to Taunton in 1906. The bridge over the road can just be seen in the background. In 1971 it had to be raised by 12 inches (30 cm) to let lorries pass underneath.

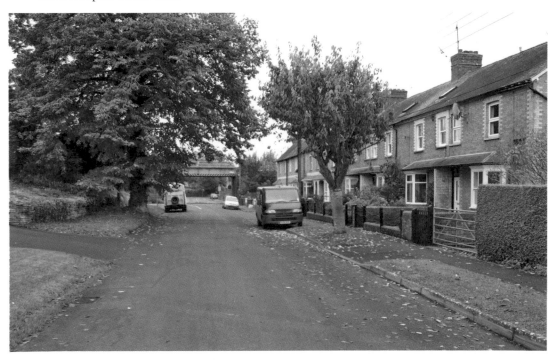

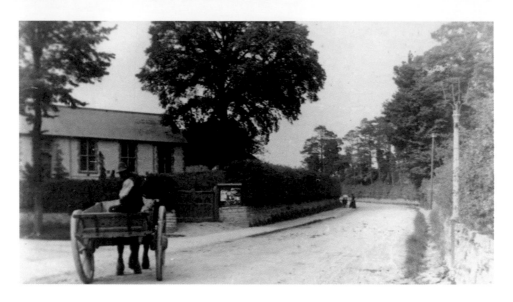

The Old Wesleyan Chapel
The Wesleyan chapel at the corner of Eastover was built in 1890. After the Second World War it was used by the Christian Brethren and was known as the Gospel Hall. It was converted to a bakery in 1979, but has now been replaced by new housing.

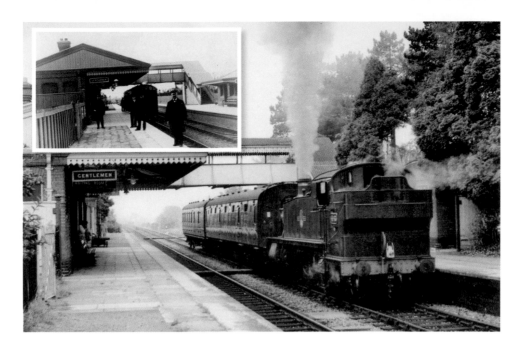

Langport East Station

The original name proposed for Langport East was Langport & Huish station, but the Editor of the local paper objected that it would be confusing, as there were too many places called 'Huish' already. The Great Western Railway opened the line in 1906, providing a direct link between London and Cornwall. Local services were provided by 'The Bucket', seen here. The station closed in 1964 and was completely demolished. Now the trains speed past without stopping.

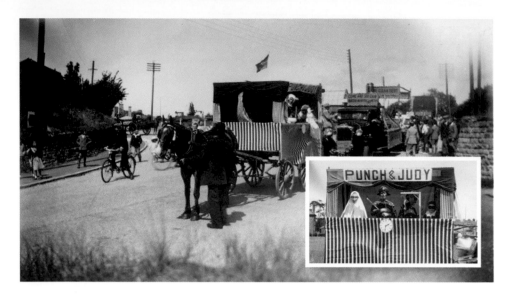

Langport Carnival

Somerset is famous for its carnival traditions, and Langport had its own from 1948 until 1984. This is a Punch & Judy float (with Douglas Webb as Toby) lined up at Shires Corner before parading through the town. A modernised Shires Garage and new housing now overlook the corner.

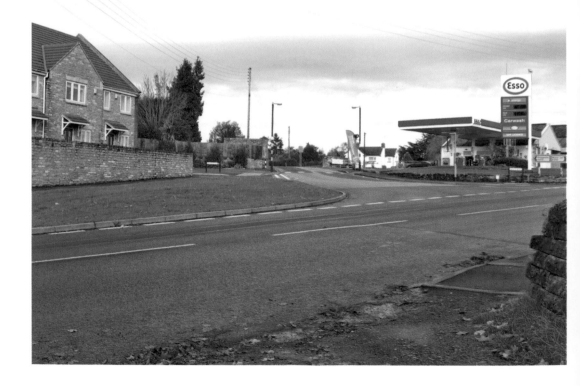

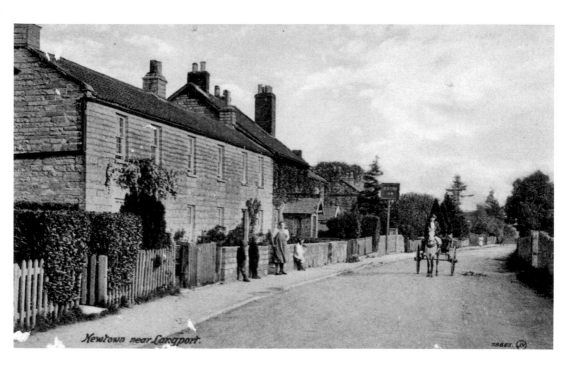

Newtown

This is a well-known view of the main road to Aller, which passes through Newtown. New housing was started here in 1845, as Langport began to expand its built-up area into Huish Episcopi, and by the time of the 1851 census, sixteen households were recorded as living in Newtown. The Newtown Inn was occupied by James Farrow and his wife Eunice. It is now a private house, and infill development is taking place behind the existing houses.

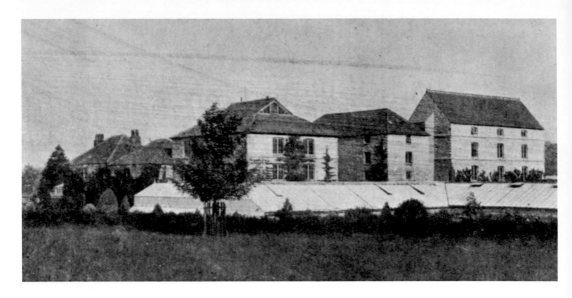

Kelways Nurseries

The Royal Nurseries, as they described themselves, were established on this site by James Kelway in 1851. Within decades they became world-famous for their herbaceous plants, especially gladioli, peonies and irises. By the end of the century they employed well over 100 people and had 45 glass houses, each 50 feet (15 m) long. The original nursery buildings included warehouses where seeds and bulbs were packed and stored. The complex is now called Old Kelways, and the buildings are used as a pub, hotel, and offices.

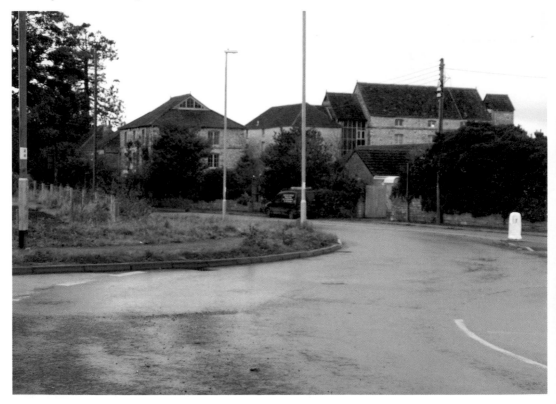

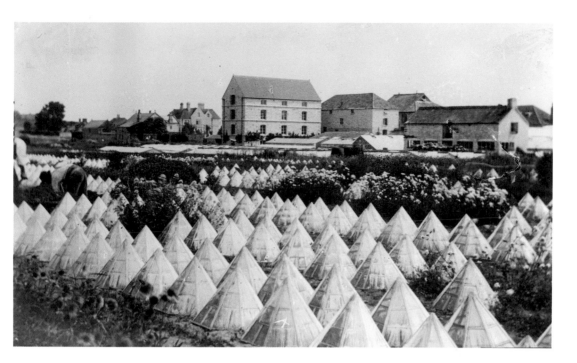

A Growing Area

This nursery field to the north of the main Kelways buildings is full of pyramid-shaped cloches, which were put over individual plants to keep different varieties from cross-pollinating. William Kelway's house, Brooklands, can be seen in the background. The only things growing in these fields now are new houses, on roads with Kelway-related names such as Peony Road and Gladiolus Road. There is now a tea room on the site called the Potting Shed.

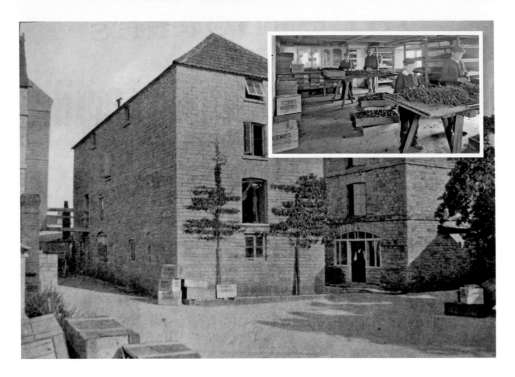

The Importance of Gladioli

Kelways built their reputation on hybridising varieties of gladiolus. The men – and boys – are packing gladiolus bulbs into boxes. The central building is the main bulb warehouse. The walkway between the two buildings has been modernised and the two joined together. The nursery business moved to Barrymore Farm, just up the road, in the 1990s.

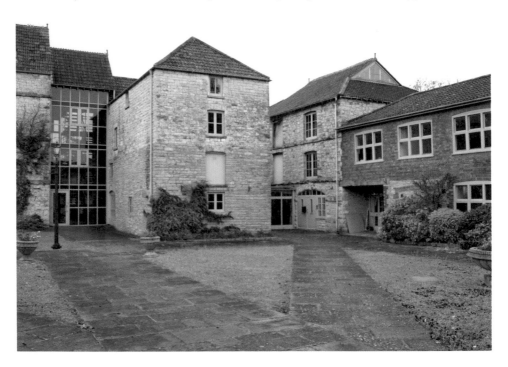

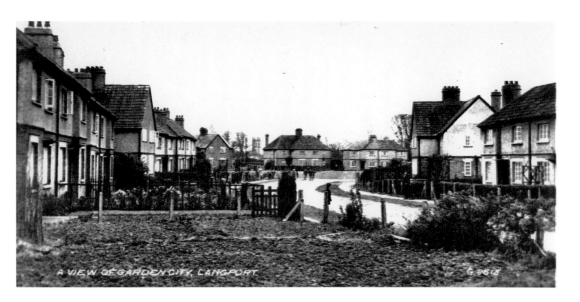

A VIEW OF GARDEN CITY, LANGPORT.

Garden City

Local authority houses were built between 1918 and 1929 on land bought from Kelways Nurseries, which gave rise to the name of Garden City. The bigger houses were built first, with extensive gardens, but later smaller houses were added in between. It used to be linked to Eastover by the footbridge over the railway at Langport East, but that was demolished along with the station buildings. Carnival floats used to assemble here, and its central green makes it a natural area for street parties.

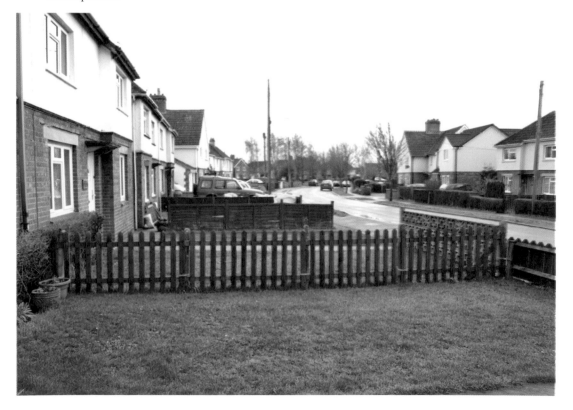

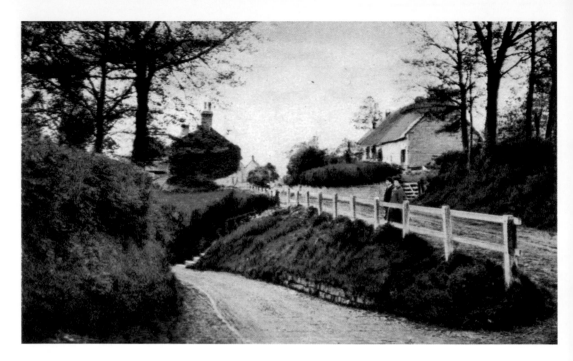

Wearne

This junction is where Wearne Lane meets the main road through Wearne. Until the late 1950s it was called Wearne Hollow because it was a hollow way (sunken lane) where the cattle drovers took their animals. Now it is vehicles that are driven down the lane.

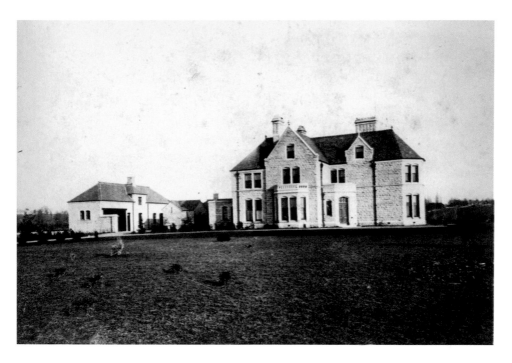

Brooklands

Brooklands was the imposing residence built in 1886 for William Kelway, son of the founder of Kelways Nurseries. When he died in 1933 the house was bought for Local Authority use and for many years it was a home for emotionally disturbed children. Renamed Redwood Grange, the main house has been converted into twelve apartments, and forms the centre of the Bartletts Elm housing development.

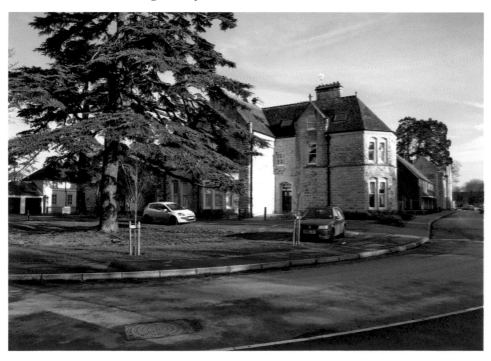

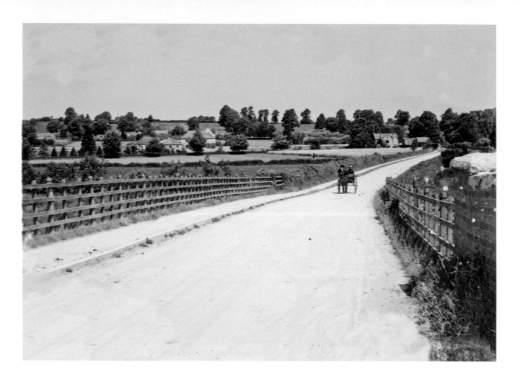

Field Road

Field Road is so called because it crosses land which formed the Common Arable Field of Huish Episcopi. The view above is taken from a glass photographic plate in Kelway's collection, and may show James Kelway's wife on her way to church. Now the nursery fields on either side have almost completely disappeared under housing estates.

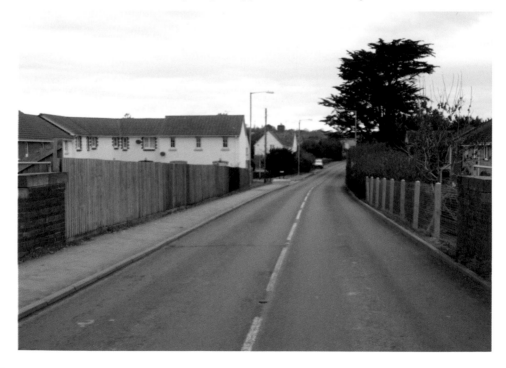

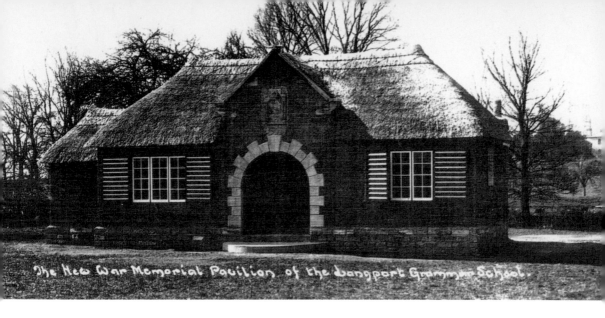

The New War Memorial Pavilion of the Langport Grammar School.

The Cricket Pavilion

This pavilion was built in memory of the master and old boys of Langport Grammar School who were killed in the First World War. It was opened on 28 March 1922 by the famous Somerset cricketer Sammy Woods. Sadly its thatch was destroyed by a fire in 1947. It is now home to the Huish & Langport Cricket Club.

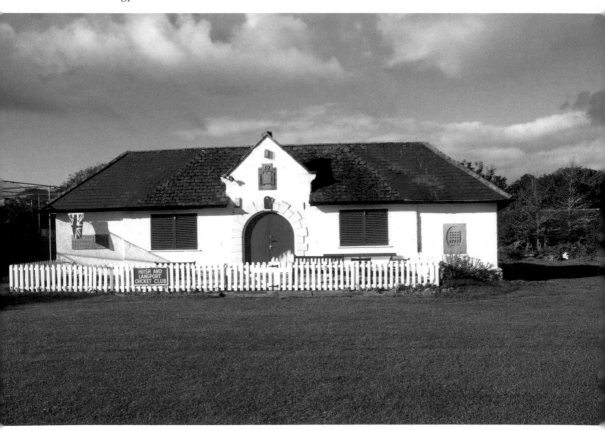

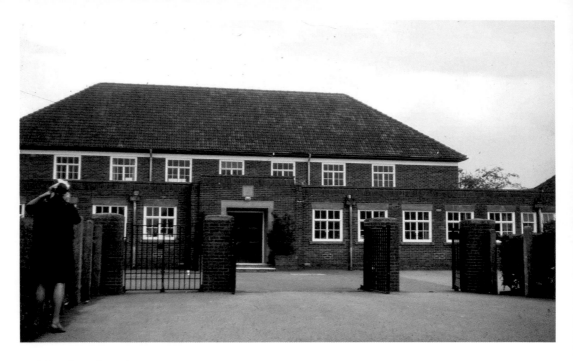

Huish Episcopi Academy

In 1940 the senior pupils from the board school in North Street were transferred to the new secondary school on Field Road, which in 1945 was known as Huish Episcopi County School. It is now Huish Episcopi Academy; a sixth form facility was opened in 2010.

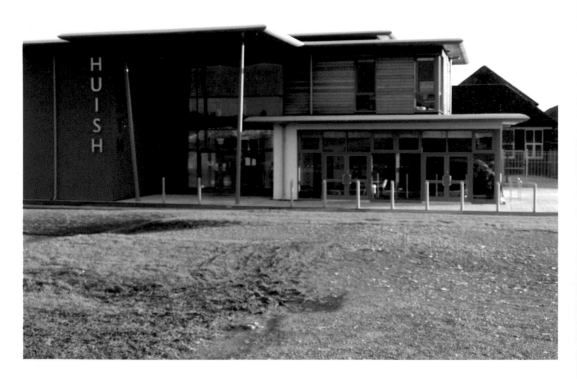

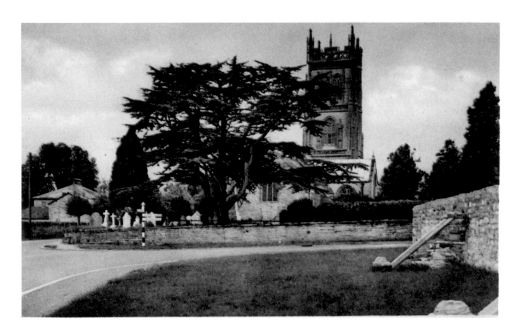

Huish Corner, St Mary's Church

St Mary's church dates back at least to the twelfth century, with many later additions. It dominates the view at this right-angled bend on the A372. The rectory roof can be seen on the far left. The spreading yew tree in the churchyard was blown down in the storm of October 1967. Near where it stood is the white marble obelisk commemorating the Kelway family of nurserymen. Their grave is still planted with the peonies that made them famous.

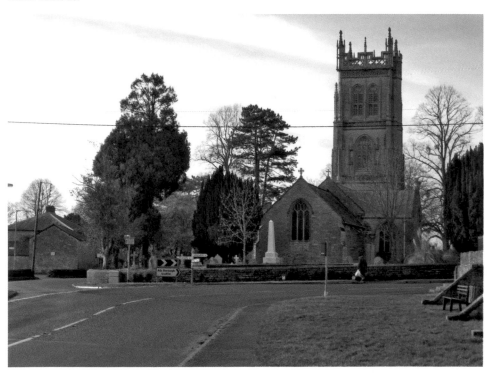

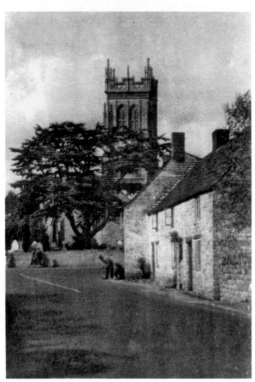

Huish Corner
The houses on the right were built as poorhouses, two tenements each with three apartments. They were sold in 1836, and were still standing at least until the 1930s. Behind where they stood is St Mary's church room, opened in 1896 and sold to the secondary school in 2009.

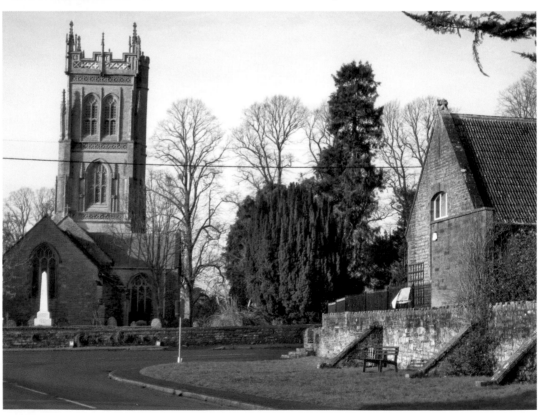

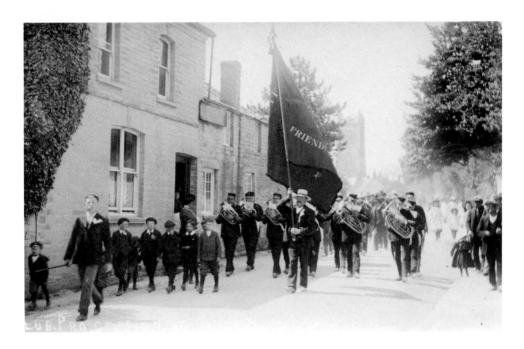

The Millers Arms

The Langport District Friendly Society is marching past the Millers Arms, a pub near Eli's in Huish Episcopi. Opposite the pub there used to be a flour mill and a sawmill, though both were disused by the early 1930s. The doorway is now a window, and the pub has become a house. The Friendly Society still holds an annual march along the same route on the Saturday nearest Oak Apple Day (27 May), a tradition that dates back to 1928.

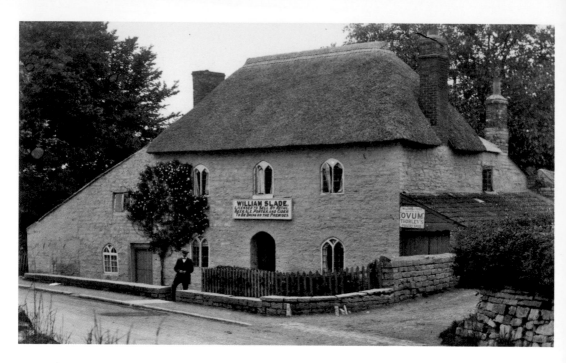

The Rose & Crown – Eli's

William Slade was landlord of the Rose & Crown from 1868 until 1923, when it was taken over by Eli Scott. It has been known as Eli's ever since, and is still owned by the same family. It is famous for having no bar counter, but an open taproom where real ales and ciders are served. Notice that the windows on the left have been improved, and there is now a pub sign.

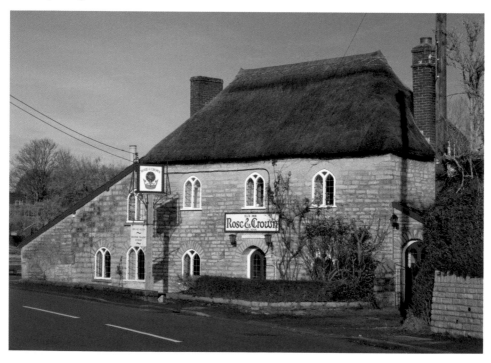

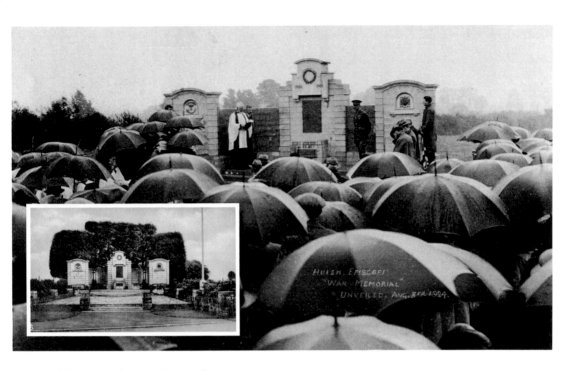

Huish Episcopi War Memorial

The war memorial was unveiled on 3 August 1924 by Captain Cuthbert Matterson, of Fivehead, in typical summer weather, in the presence of over 400 people. Twenty years later it was shrouded by a large hedge, which has since disappeared.

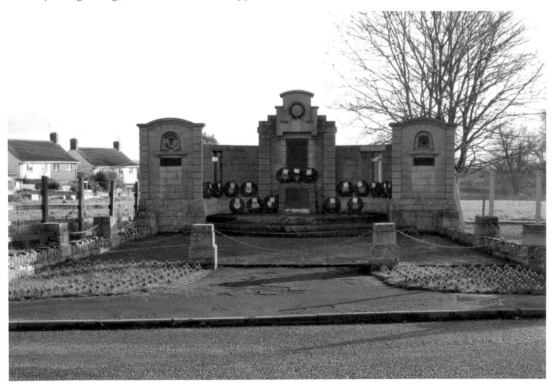

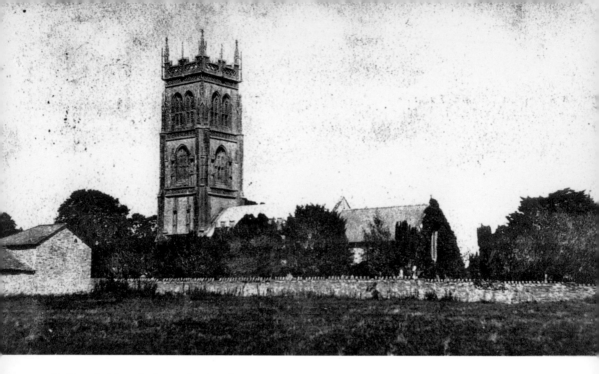

St Mary's Church, from the South
The church of St Mary, Huish Episcopi, has long been admired for its fine 99-foot (30-m) Perpendicular tower of blue lias and hamstone. It also boasts a fine stained-glass window designed by Burne-Jones and dedicated to the nurseryman James Kelway. The much-needed car park, which has colonised the field across the road, also serves the nearby secondary school.

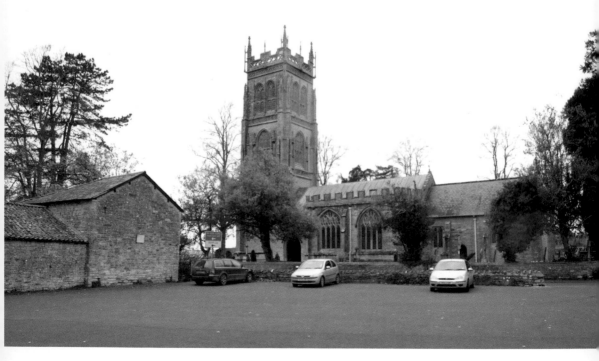

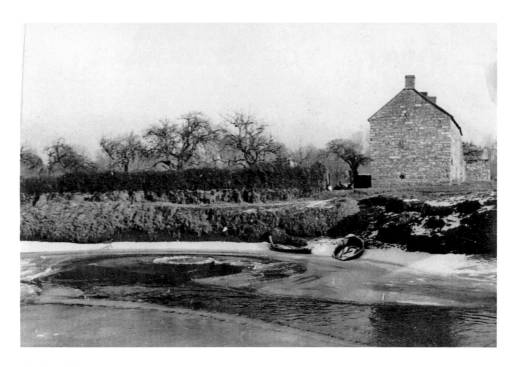

Black Bridge Cottage

Black Bridge Cottage was occupied by Ken Crumb's maternal grandparents, William and Lilly Knowles, from at least 1901. William's boats are in the foreground. When it flooded, they simply lived upstairs, and there was a wall which they could walk along the top of to get to dry land. William died in 1943, and the cottage became derelict. It has now completely disappeared, and a small car park by the bridge has taken its place.

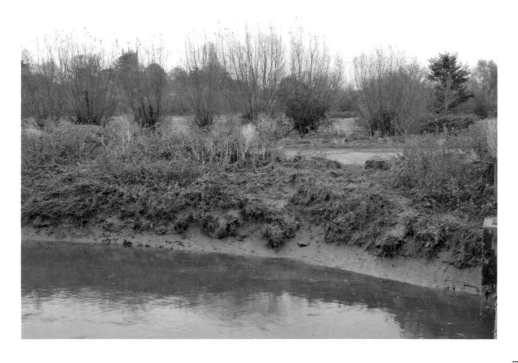

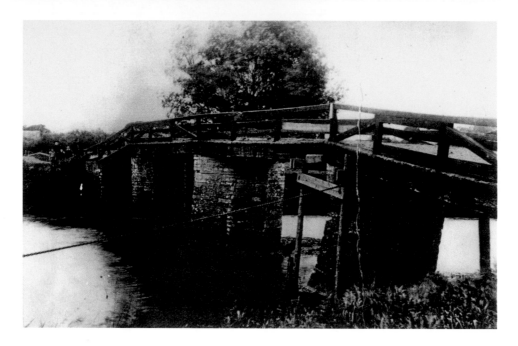

Huish Bridge

This bridge connects the parts of Huish parish that are on either side of the River Parrett. Huish Bridge is mentioned in 1581, and was destroyed by the King's forces in 1646. A 1791 reference to a bridge of wood, standing on four stone piers, could be the one pictured above. In 1870 it was replaced by an iron bridge, known as Black Bridge. The functional concrete bridge that replaced it in 1978 is still called 'Black Bridge' by local residents.

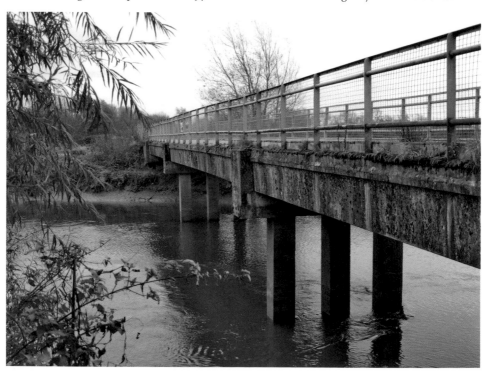

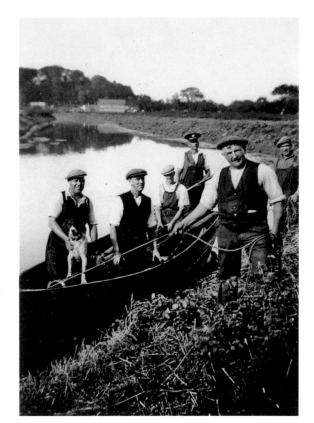

Fishing in the Parrett

The river workers at Black Bridge landing stage could have been cutting the vegetation on the banks, or possibly fishing for eels or pike. The baker, Ernest William Brown, and his son Ronald display their magnificent catch of thirteen pike in 1912, minus one 'left in the boat in error'. There are still fish to be had in the Parrett, though not as large as the ones in 1912. Westover can be seen in the distance.

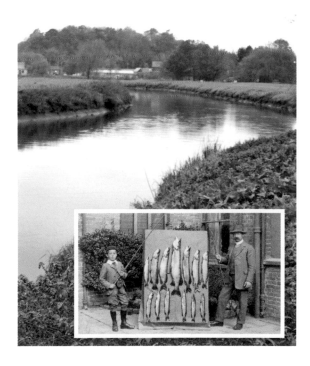

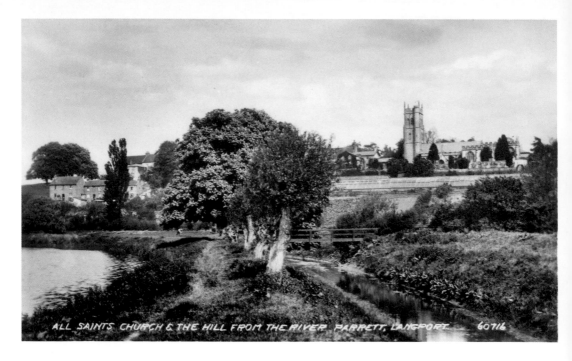

ALL SAINTS CHURCH & THE HILL FROM THE RIVER PARRETT, LANGPORT. 60716

Walking Beside the River Parrett

A footpath follows the River Parrett from Cocklemoor, in the town centre, to Huish Bridge, from where this view can be taken. Many more trees have been planted since the above image was recorded, and the wet season of 2012 has left the path extremely muddy. The footbridge to the right leads to Bennetts Lane, which winds steeply back up to The Hill.

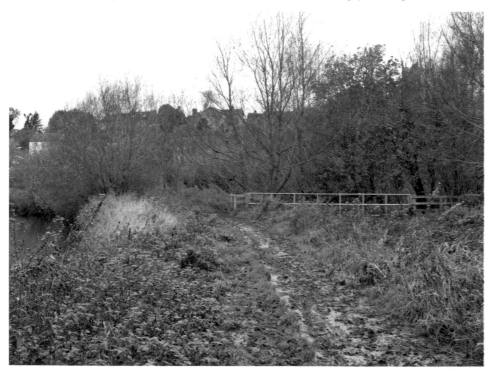

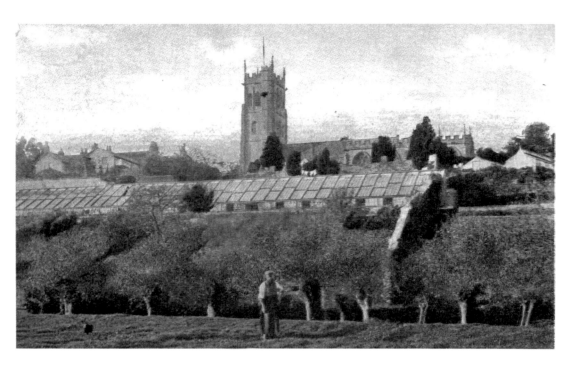

All Saints Church from the Riverbank
The extensive glasshouses belonged to James Lloyd, who ran a market garden on The Hill for nearly fifty years until the Second World War. The willows mark the line of the Long Sutton Catchwater. Houses have now been built on most of the site.

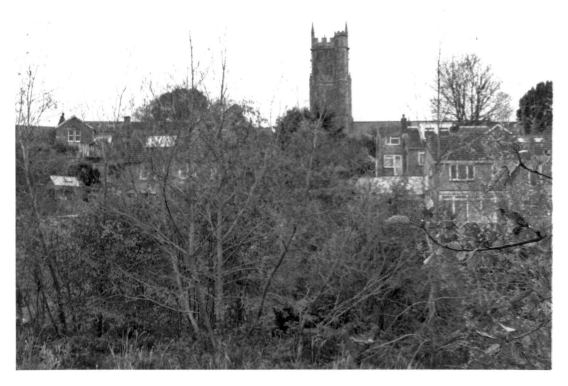

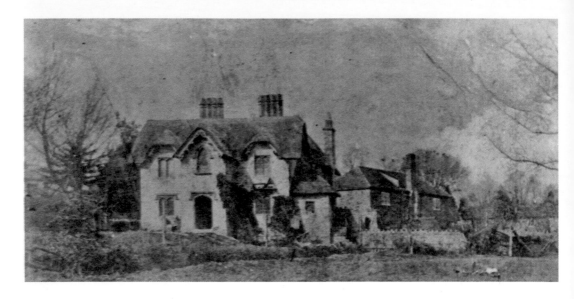

The Old School House on The Hill

The house in the foreground is one of a pair of unusual semi-detached cottages, built for the schoolmaster and schoolmistress of the town. The Old School House is the house for the schoolmaster. They are built of local lias stone with hamstone dressings, and the gables have intricately decorated bargeboards. In the background is the first National Day School, which was opened in 1827 and demolished by 1903. Although no longer thatched, the cottages retain their attractive frontages.

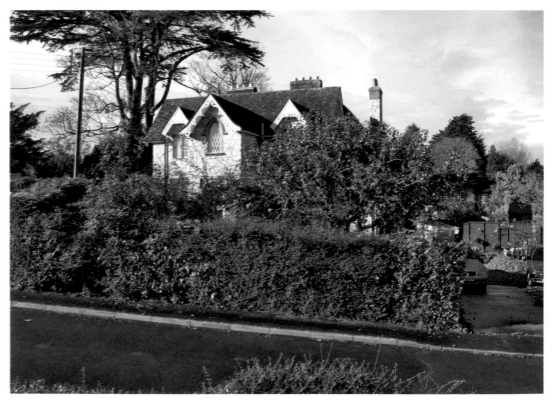

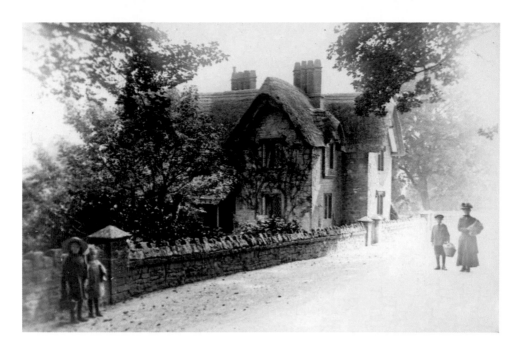

The Beeches

The schoolmistress occupied this pretty nineteenth-century Gothic style cottage, the other half of the Old School House. In 1833 there was a day school and a Sunday school for eighty children, but when the Board School opened in 1876, the day school was no longer needed. The house now has a tiled roof, and the beech trees for which the house was named succumbed to disease and had to be cut down.

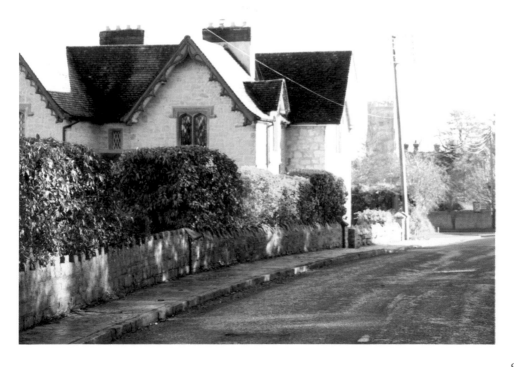

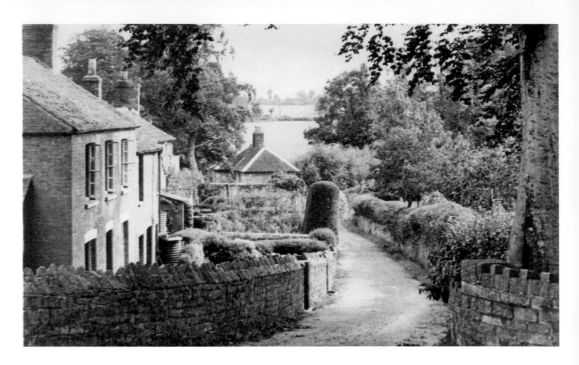

Bonds Pool

The name of Bonds Pool Lane, which runs north from The Hill, may refer to an ancient obligation to maintain part of Langport Field, which was at the far end. Until 1836 there was a path linking this to Priest Lane. Little has changed since the photograph above was taken in 1948, apart from the carved beech tree trunk on the right.

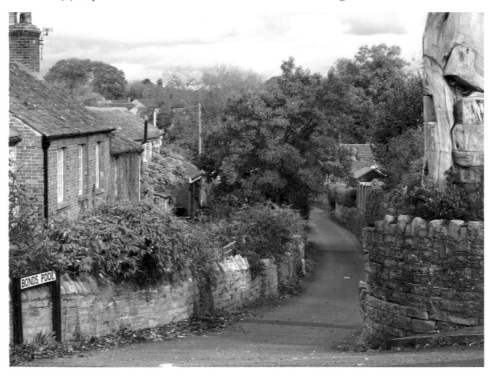

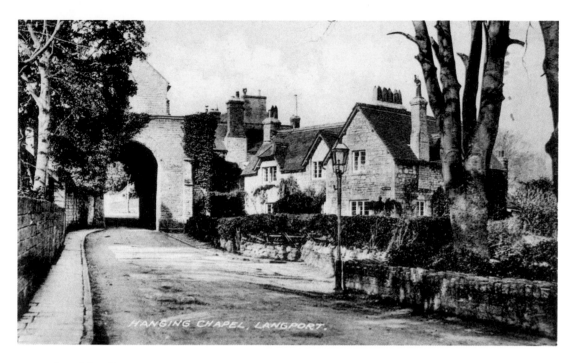

HANGING CHAPEL, LANGPORT.

The Old Police House

The house with the large gable at the corner of Bonds Pool was at one time the Police House, occupied by Police Constable Wilf Standen. The brick chimneys in the background belong to the former rectory to All Saints church. The fine beech trees on the right were diseased, and had to be cut down. One of the trunks has been carved into the shape of a dragon.

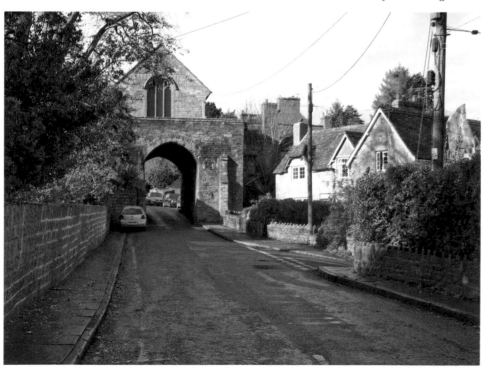

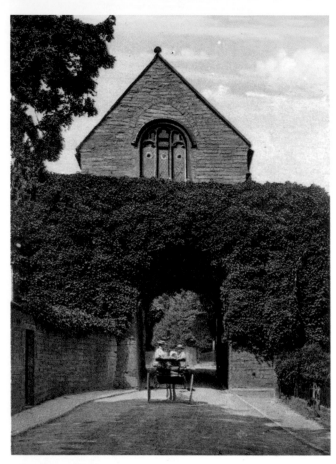

The Hanging Chapel, Looking West

In this view of the east side of the Hanging Chapel there is plenty of room for a horse and cart, and indeed for a car. A military tank on a tank carrier, however, got stuck underneath in 1944 and did a considerable amount of damage. This pair of images also clearly shows the straightening of the roof.

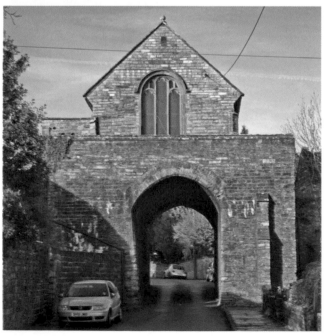

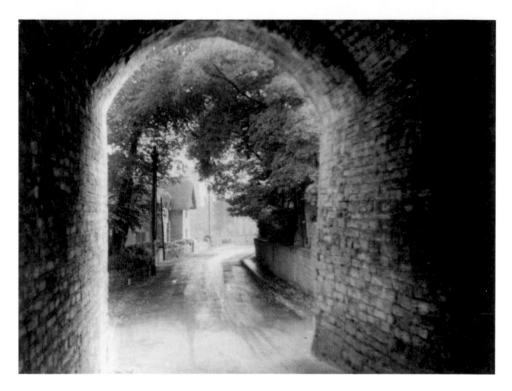

Underneath the Archway, Looking East
This view from under the vaulted archway of the Hanging Chapel frames on the left the gable end of one of the old schoolhouses, now called The Beeches. The wall to the right forms the boundary of The Gateway, a fine house whose imposing trees now dominate the skyline.

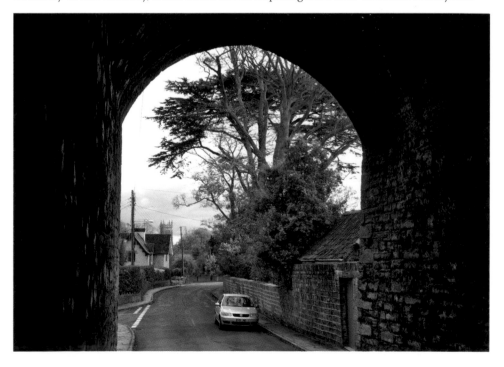

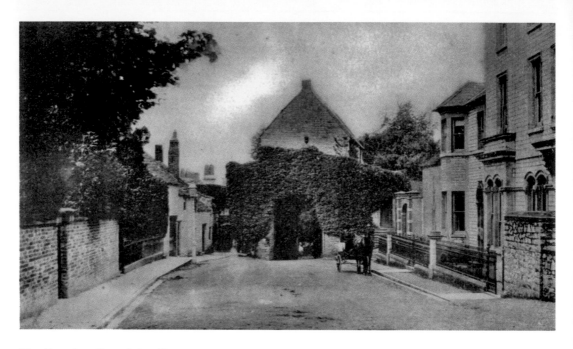

The Hanging Chapel, Looking East

Langport's most famous landmark was built as a medieval chapel over the eastern approach to the town. So-called because it 'hangs' over the road, it has had many uses over the years – school, museum, town hall, armoury. Shortly after the above photograph was taken it was leased by the Portcullis Lodge of Freemasons, who still use it today. A recent road safety improvement was the creation of a footpath around the outside on its north side.

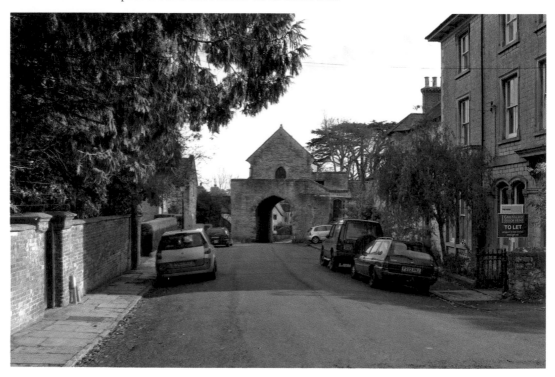

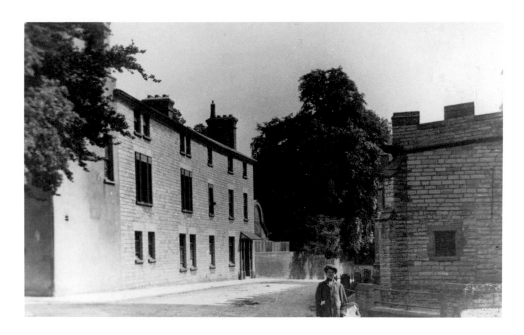

St Joseph's Church

The back of St Gildas convent faces All Saints church across The Hill. In 1929 the church of St Joseph was built, attached to the convent, to provide a convenient place of Catholic worship. The semicircular extension at the far end was added in 1965.

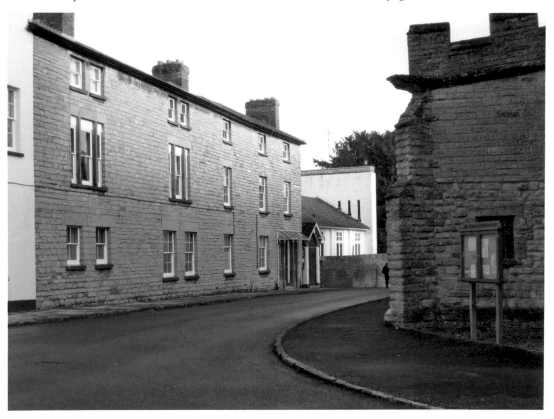

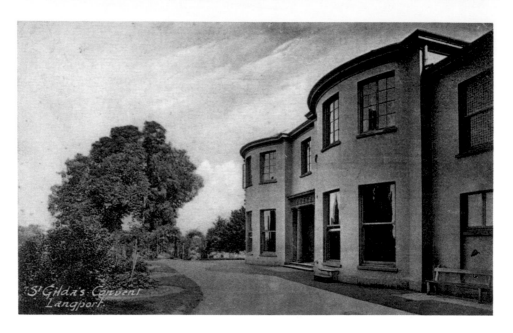

St Gildas

St Gildas convent is an early nineteenth-century mansion, originally built for Vincent Stuckey and called Hill House. In 1903 it was bought by the Sisters of Christian Instruction of St Gildas, who came to England to take refuge from difficult times in France. The girls' school closed in the 1970s and in 1991 the closure of the primary school led to the end of the convent and the nuns' departure. It is now a Catholic retreat centre. The May Day celebrations probably date from 1991.

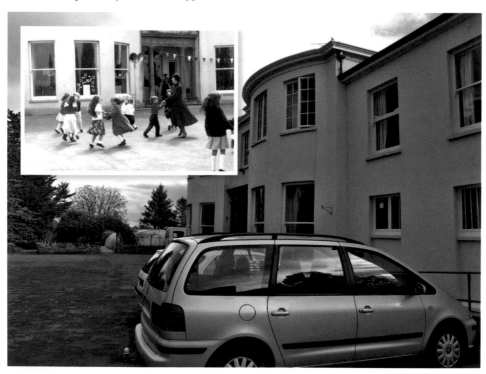

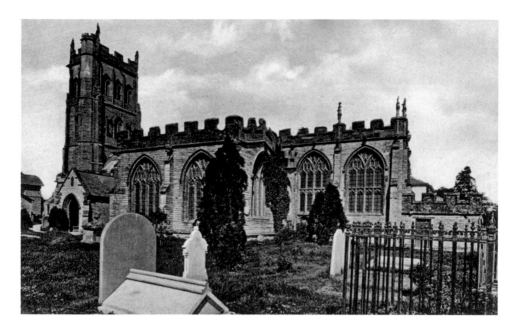

All Saints Churchyard

This view of All Saints from the south-west shows the elaborate tracery above the medieval windows. The medieval stained glass in the east window is considered very fine. The churchyard contains the graves of Walter Bagehot, famous economist and journalist, and William Quekett, headmaster of Langport Grammar School for fifty-two years. Some gravestones and trees have been cleared away in the modern view.

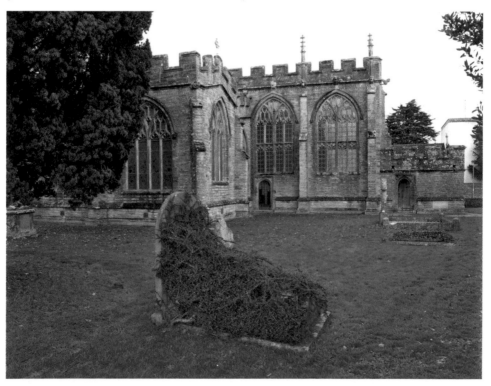

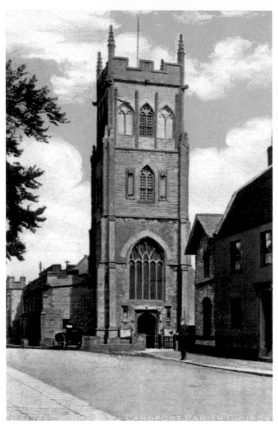

All Saints, Langport

The medieval church of All Saints, Langport, has a particularly tall west tower (84 feet, 25 m). At the top, the portcullis of Lady Margaret Beaufort proclaims her ownership of the manor in the fifteenth century. The window above the west door is dedicated to the memory of Walter Bagehot, who is buried in the churchyard. Declared redundant in 1995, the church is now in the care of the Churches Conservation Trust.

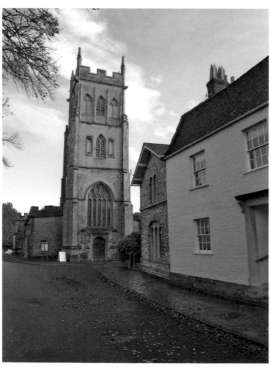

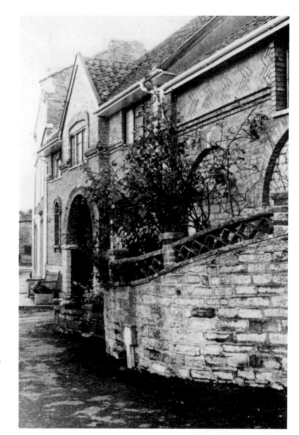

The Gatehouse

The Gatehouse has an elaborate brick design and was formerly the carriage entrance to Riversleigh, a fine house once occupied by Edward Quekett. Edward was a banker in the town and the son of William Quekett, long-time headmaster of Langport Grammar School. The side wall has been altered, and the iron gates in the central archway have been replaced by solid wooden doors.

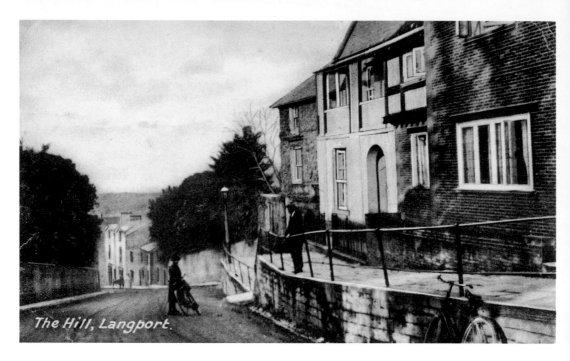

The Hill, Langport.

The Hill, Looking West

The three houses at the top of The Hill, (left to right) Annandale, the French House and the Red House, define this view looking to the north-west of Langport. The railings still lean outwards in the same place.

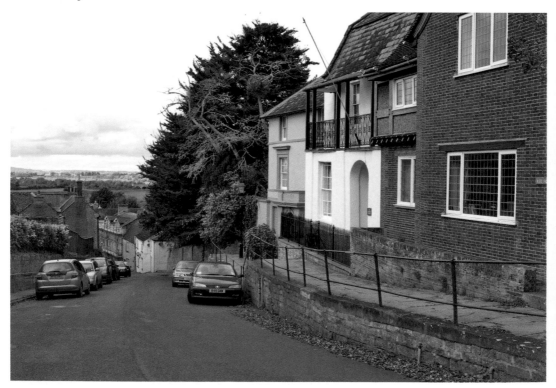

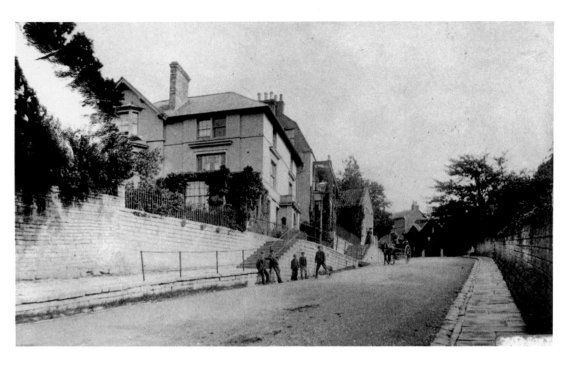

Up The Hill

The steepest part of The Hill was originally known as Up Street, and remained so until the mid-nineteenth century, when it became The Hill. A market was held at the top in the sixteenth century, but was eventually moved down to Cheapside. The large house on the left is Annandale.

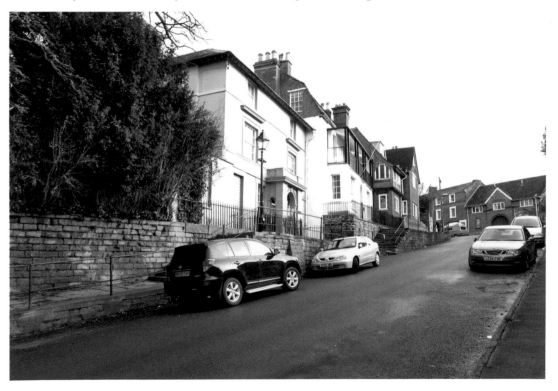

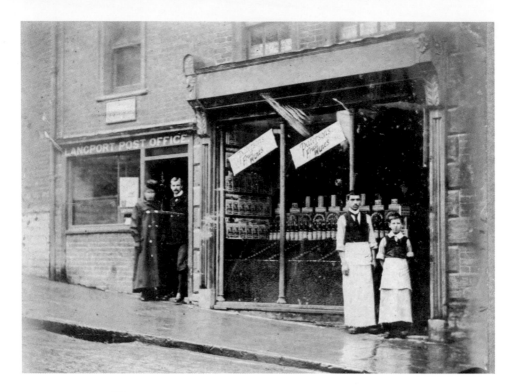

Langport Post Office

This post office at the bottom of The Hill began as part of Challis' Stores, but the premises were separate by 1910. The couple in the doorway could be Charles Jeal, who took over as postmaster when Alfred Challis retired, and his wife Ruth. After a few years the post office moved into its present building across the road, which had previously been the sorting office. At some stage the two frontages have been made to match.

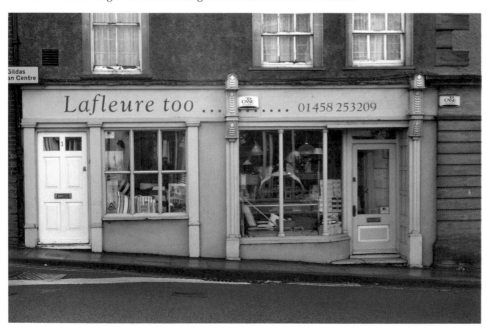